ISBN 978-1-941250-15-0
First Edition, March 2017
Printed in France.

DISTRIBUTED TO THE TRADE BY
Consortium Book Sales & Distribution
LLC. 34 Thirteenth Avenue NE
Suite 101, Minneapolis, MN 55413-1007.
cbsd.com, Orders: (800) 283-3572

ododbooks.com

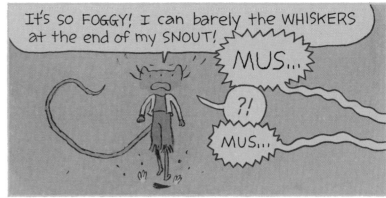

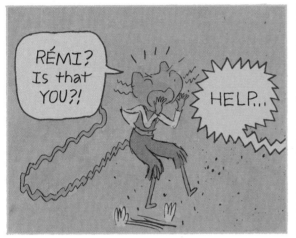

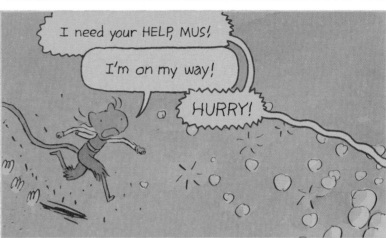

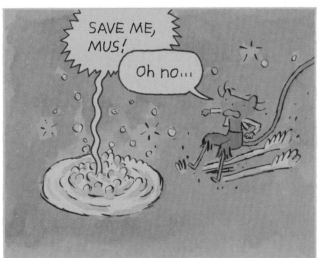

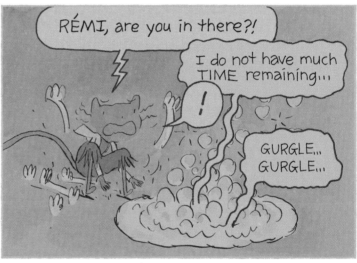

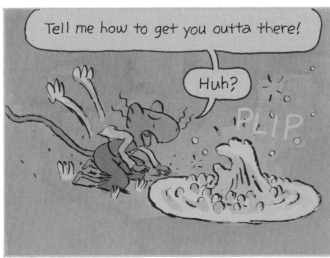

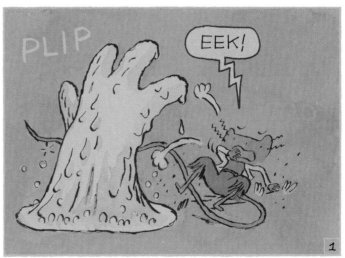

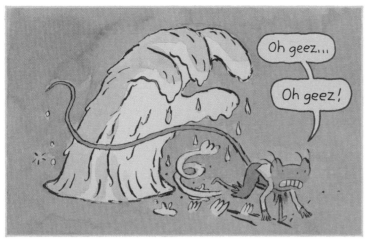

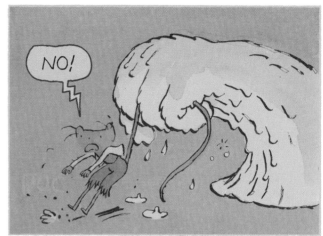

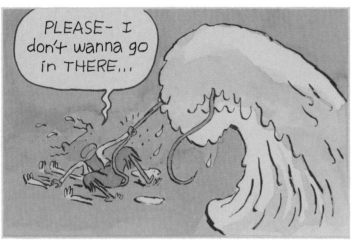

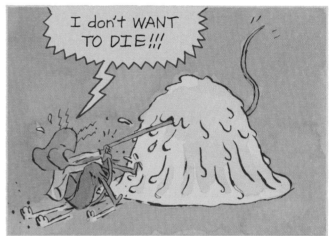

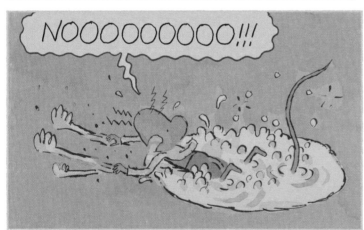

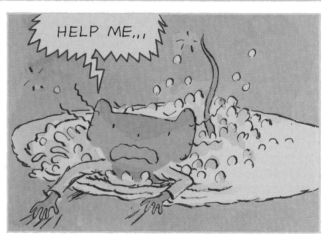

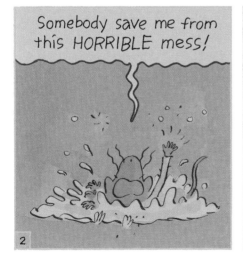

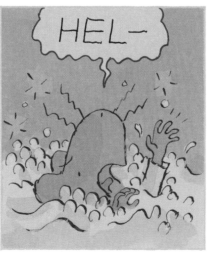

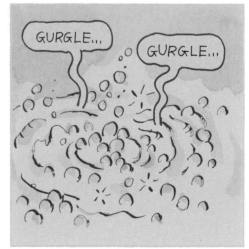

KICKLIY

THE FLAMES OF THE LIMELIGHT

ODOD
BOOKS

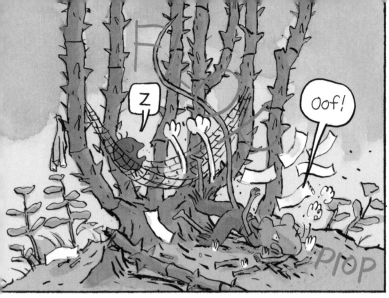

Z

Oof!

PIOP

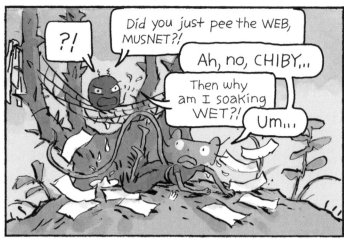

?!

Did you just pee the WEB, MUSNET?!

Ah, no, CHIBY...

Then why am I soaking WET?!

Um...

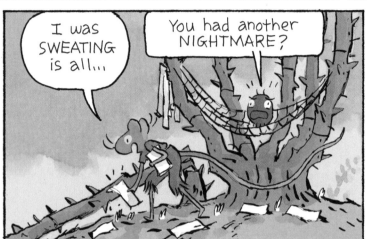

I was SWEATING is all...

You had another NIGHTMARE?

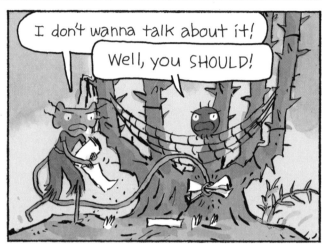

I don't wanna talk about it!

Well, you SHOULD!

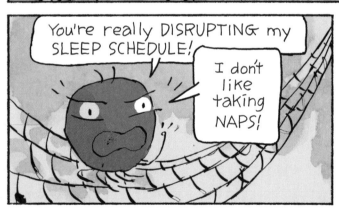

You're really DISRUPTING my SLEEP SCHEDULE!

I don't like taking NAPS!

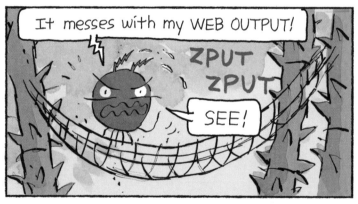

It messes with my WEB OUTPUT!

ZPUT ZPUT

SEE!

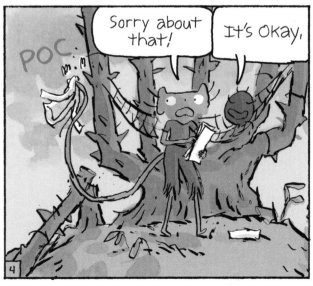

POC

Sorry about that!

It's okay,

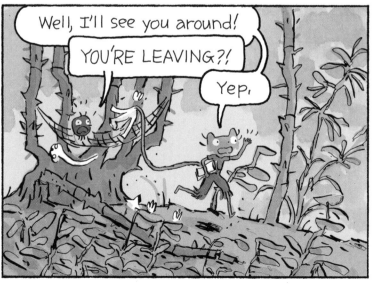

Well, I'll see you around!

YOU'RE LEAVING?!

Yep,

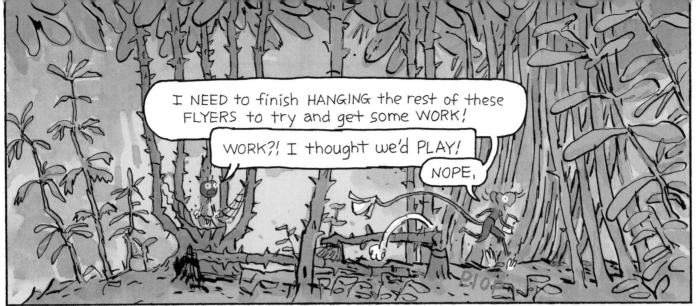

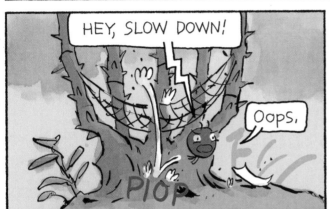

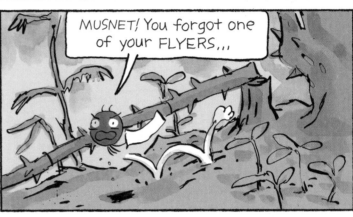

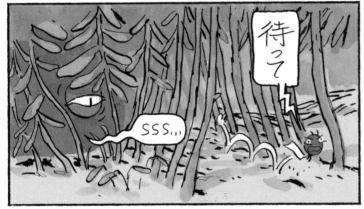

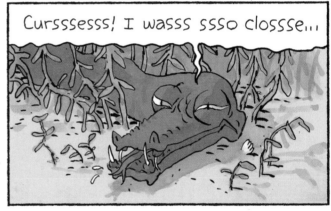

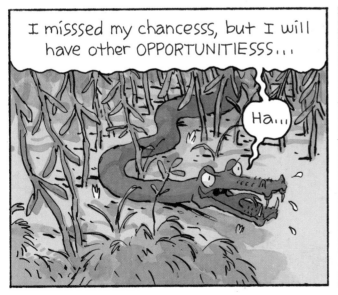

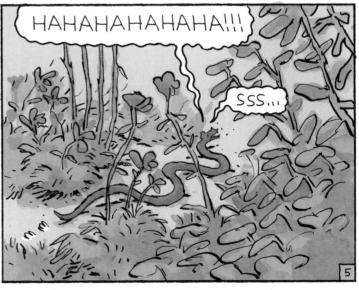

SOON:

WAIT UP, would you?!

NO - I'm done waiting!

Huh?

Rodents aren't gonna MAGICALLY need a PAINTING from me. I'm the one who's gotta make it happen!

Okay...

Well, if you think about it, who really NEEDS a painting anyway? I THINK what you meant to say was "WANT"!

PFFT!

WANT, NEED - Same thing!

Ah... No it's not.

WHATEVER!

Listen - I'm not gonna make any CHEDDAR by ARGUING with you.

I'm not trying to ARGUE!

I know,

Then what's with all the ATTITUDE?!

Sigh...

I'm just STRESSED OUT about Mya's family PROBLEMS.

I guess I just needed to VENT.

WORK FOR HIRE

I UNDERSTAND!

That's what FRIENDS are for - RIGHT?

ハハ!

You know, whatever happens, you're always welcome to stay at my PARENTS' place,

I know,

They'd be happy to serve you-- Um—As a GUEST—Not as a MEAL...

Gee, thanks for the offer,

But I've gotta pay back Mya's family for SUPPORTING me this whole time...

HOP

I OWE them that!

PLOP

All I've been able to give them is some CRUMBY beginner paintings— And that's not gonna help pay their RENT!

You know what?

WHAT?!

PLOP PLOP PLOP

You NEED a more POSITIVE view of your PAINTINGS!

Easy for you to say!

ACTUALLY, It'd be easier for me to say in JAPANESE!

Ooh...This is a PRIME LOCATION!

BANK

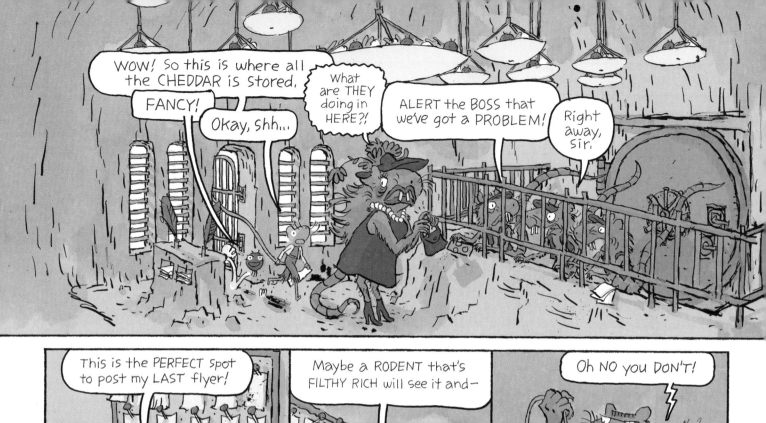

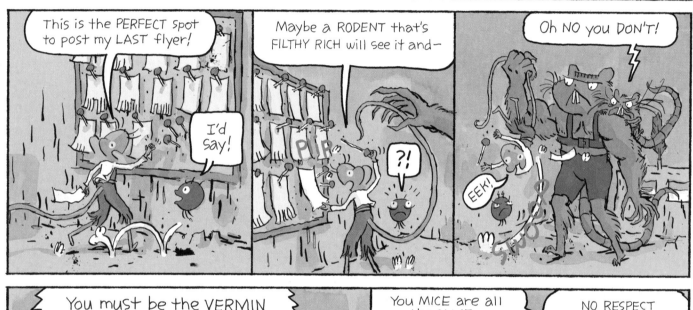

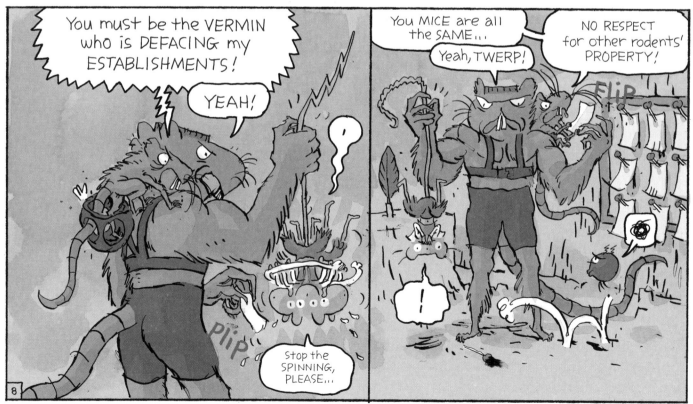

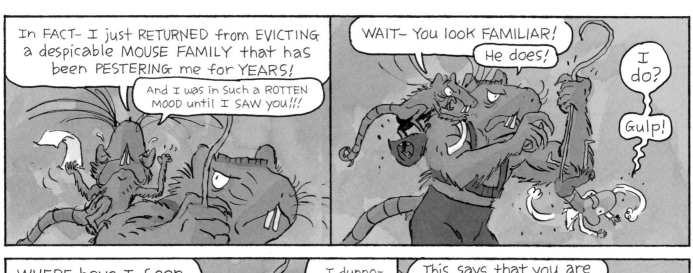

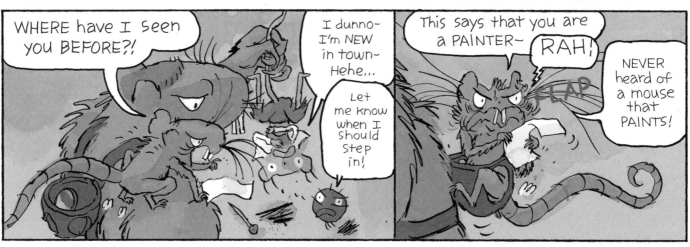

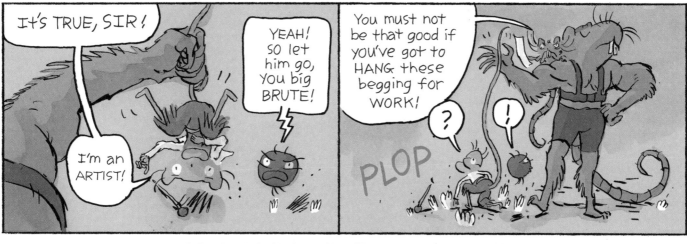

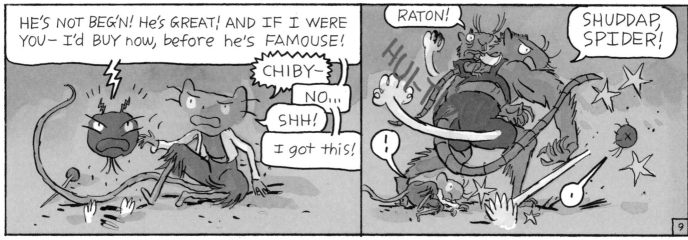

What an INSULT!

?

ZPUT ZPUT

Oh no!

CRASH

痛い！

That CHEESE ENHANCED RAT is LUCKY that my WEB output is all out of WACK!

PIOP PIOP

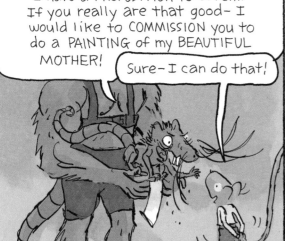

I have a PROPOSITION to offer... If you really are that good— I would like to COMMISSION you to do a PAINTING of my BEAUTIFUL MOTHER!

Sure— I can do that!

Then MEET me at my MANSION in the WOODS later today to discuss the PARTICULARS! You do know where I LIVE, don't you, MOUSE?!

Yes, MR. RATTISON. Everyone does.

RAH!

PIOP

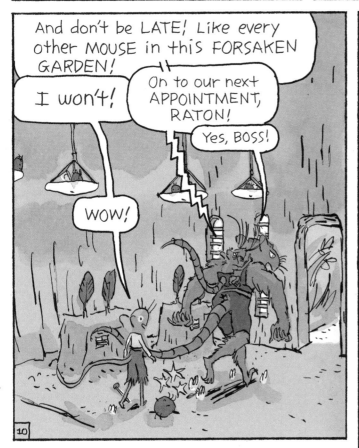

And don't be LATE! Like every other MOUSE in this FORSAKEN GARDEN!

I won't!

On to our next APPOINTMENT, RATON!

Yes, BOSS!

WOW!

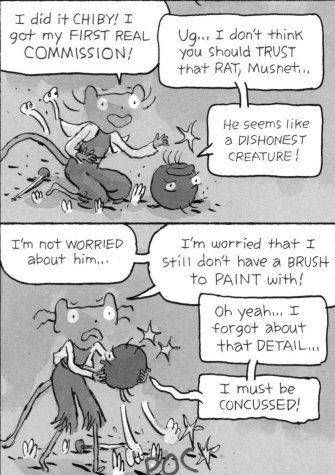

I did it CHIBY! I got my FIRST REAL COMMISSION!

Ug... I don't think you should TRUST that RAT, Musnet...

He seems like a DISHONEST CREATURE!

I'm not WORRIED about him...

I'm worried that I still don't have a BRUSH to PAINT with!

Oh yeah... I forgot about that DETAIL...

I must be CONCUSSED!

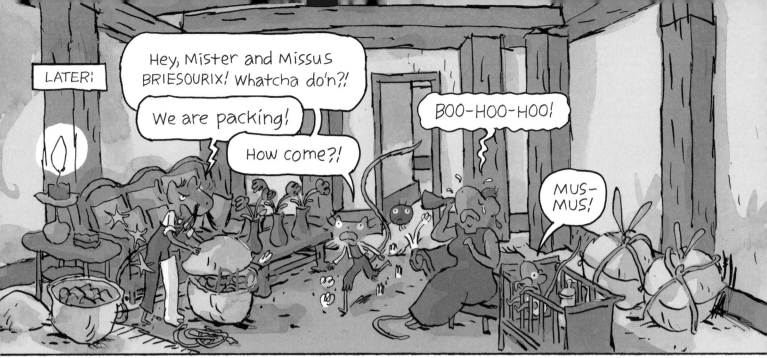

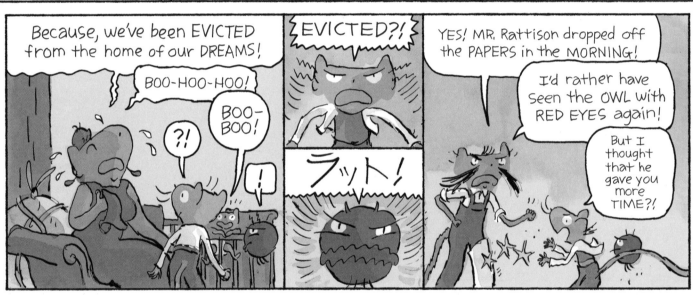

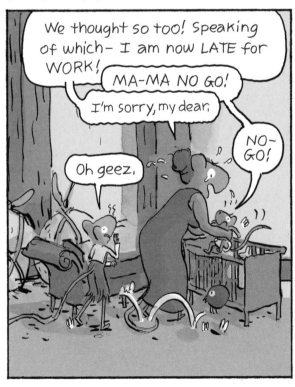

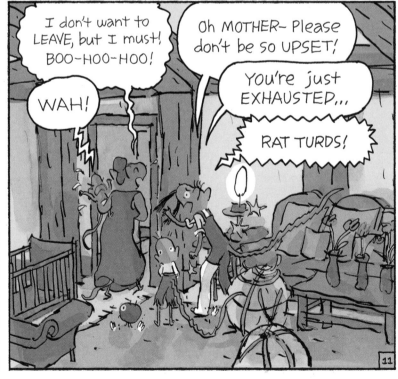

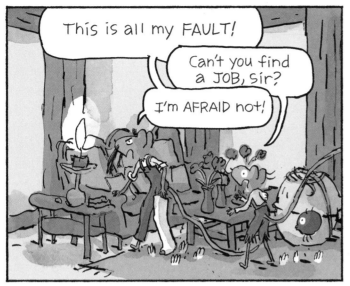

This is all my FAULT!

Can't you find a JOB, sir?

I'm AFRAID not!

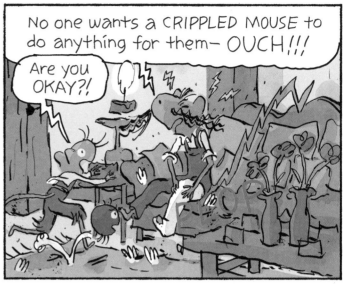

No one wants a CRIPPLED MOUSE to do anything for them— OUCH!!!

Are you OKAY?!

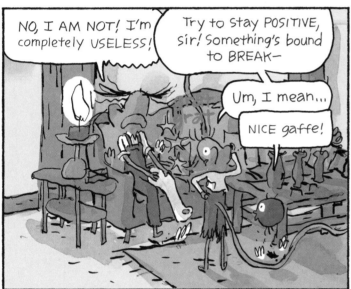

NO, I AM NOT! I'm completely USELESS!

Try to stay POSITIVE, sir! Something's bound to BREAK—

Um, I mean...

NICE gaffe!

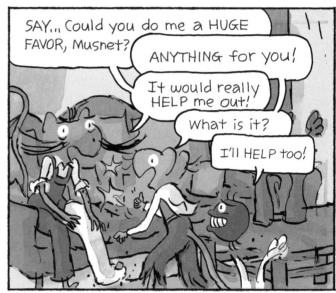

SAY... Could you do me a HUGE FAVOR, Musnet?

ANYTHING for you!

It would really HELP me out!

What is it?

I'll HELP too!

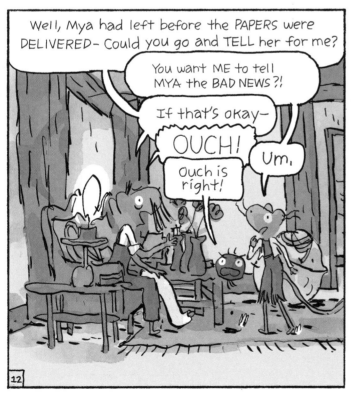

Well, Mya had left before the PAPERS were DELIVERED— Could you go and TELL her for me?

You want ME to tell MYA the BAD NEWS?!

If that's okay—

OUCH!

Um,

Ouch is right!

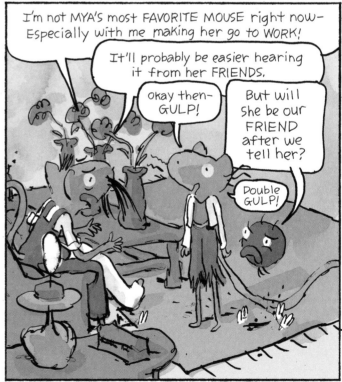

I'm not MYA'S most FAVORITE MOUSE right now— Especially with me making her go to WORK!

It'll probably be easier hearing it from her FRIENDS.

okay then— GULP!

But will she be our FRIEND after we tell her?

Double GULP!

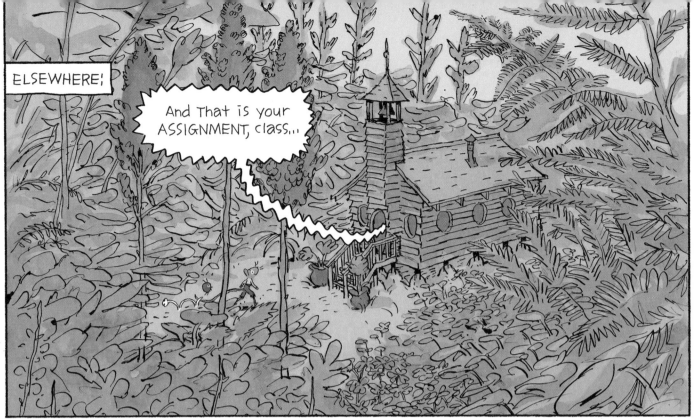

And That is your ASSIGNMENT, class...

Please turn with me to page THIRTEEN in your SCHOOL BOOKS.

YES, MISS BRIESOURIX!

?!

Who's that?

Class, I've changed my mind...

You may go OUTSIDE for RECESS instead!

HURRRRRRRRAY!!!

STAMPEDE!

EEK!

WOOOSH

It's STRANGE seeing you all dressed up like an ADULT, MYA!

HAHA! Very funny!

So, how's the NEW job?

It's okay, I guess...

I am a bit WORN OUT!

13

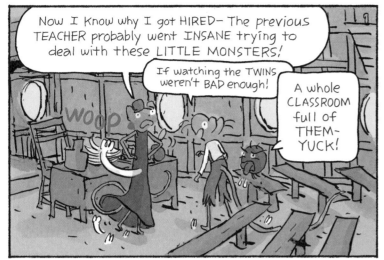

Now I KNOW why I got HIRED— The previous TEACHER probably went INSANE trying to deal with these LITTLE MONSTERS!

If watching the TWINS weren't BAD enough!

A whole CLASSROOM full of THEM— YUCK!

WOOP!

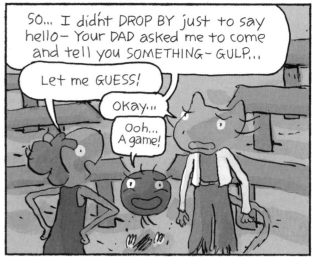

SO... I didn't DROP BY just to say hello— Your DAD asked me to come and tell you SOMETHING— GULP...

Let me GUESS!

OKAY...

Ooh... A game!

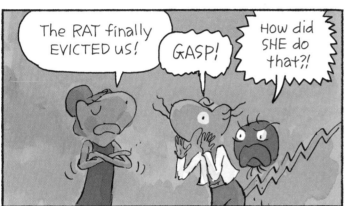

The RAT finally EVICTED us!

GASP!

How did SHE do that?!

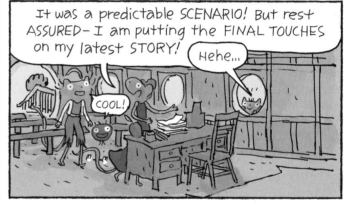

It was a predictable SCENARIO! But rest ASSURED— I am putting the FINAL TOUCHES on my latest STORY!

Hehe...

COOL!

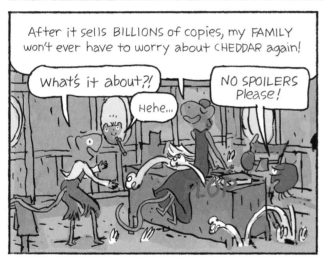

After it sells BILLIONS of copies, my FAMILY won't ever have to worry about CHEDDAR again!

What's it about?!

Hehe...

NO SPOILERS Please!

PLOP

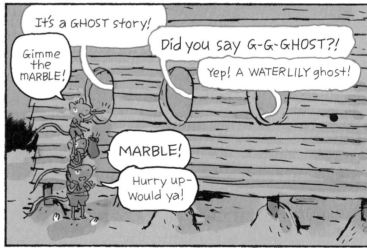

It's a GHOST story!

Gimme the MARBLE!

Did you say G-G-GHOST?!

Yep! A WATERLILY ghost!

MARBLE!

Hurry up— Would ya!

Speaking of GHOSTS— How is RÉMI doing?!

I don't know. He still won't TALK to ME!

PLOP

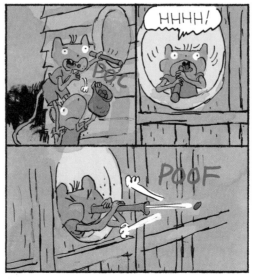

HHHH!

POOF

PATANG

ENCRE

BAM

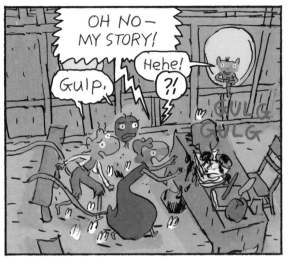

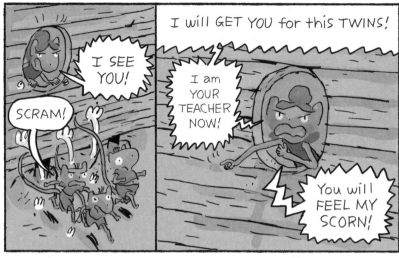

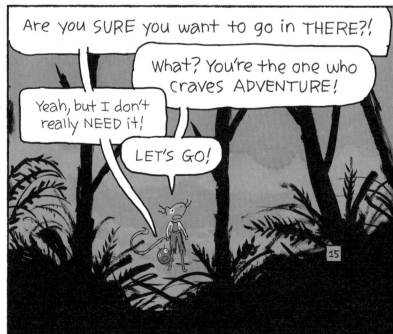

15

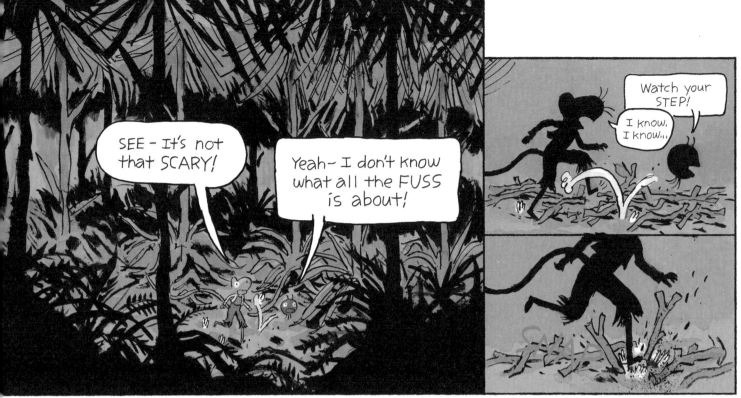

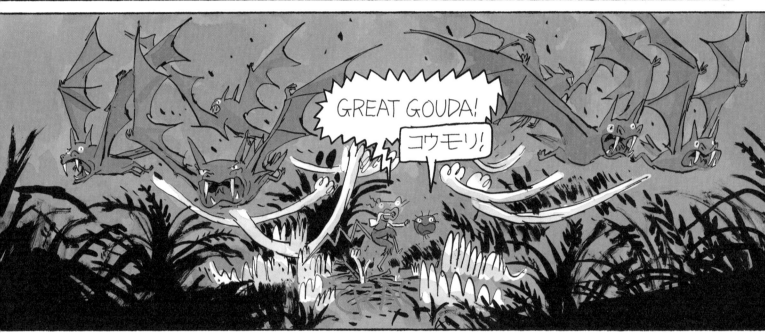

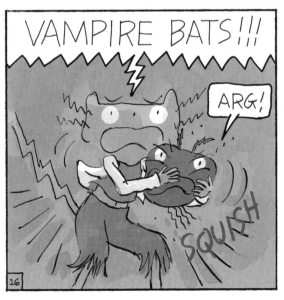

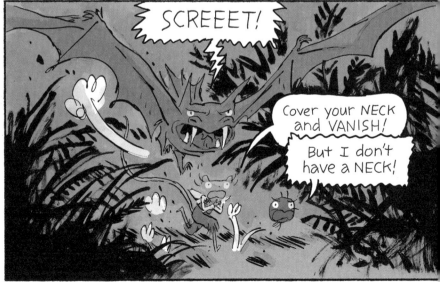

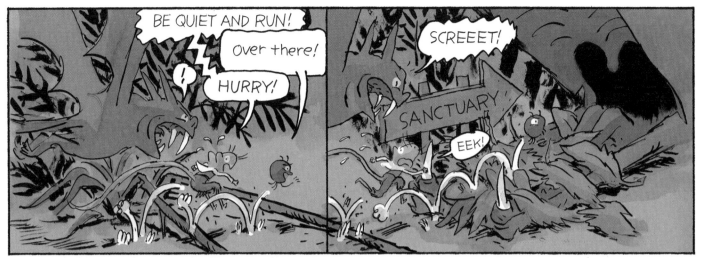

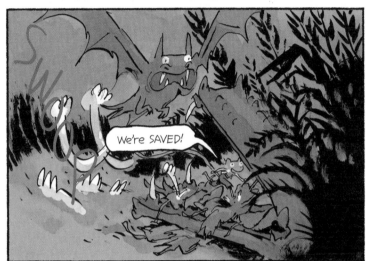

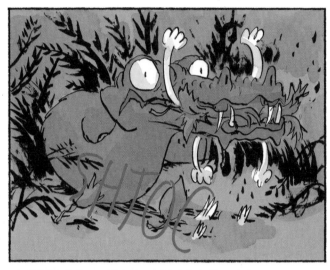

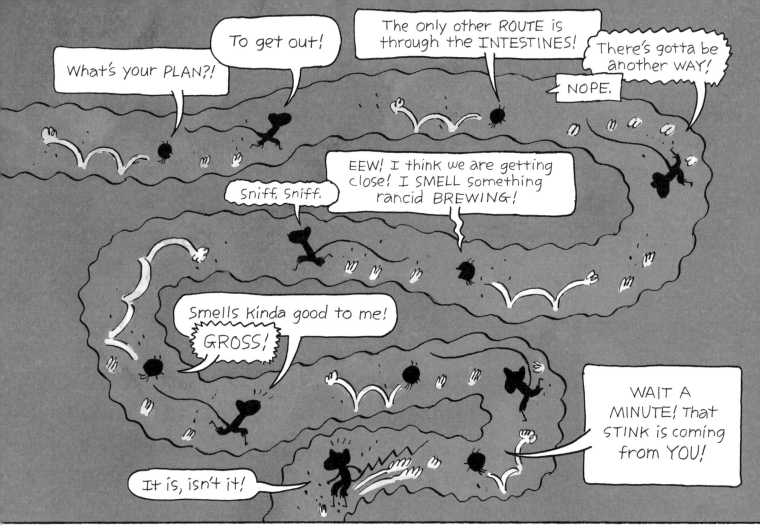

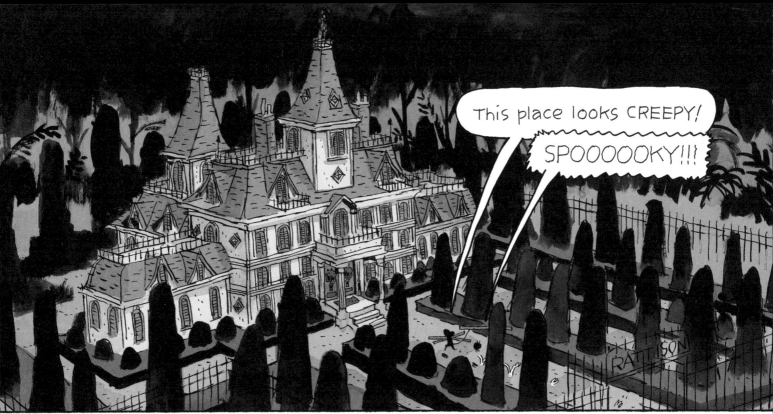

This place looks CREEPY! SPOOOOOKY!!!

You KNOCKED?!

Hello,

Remember me? I'm the PAINTER!

We have an APPOINTMENT with MR. RATTISON!

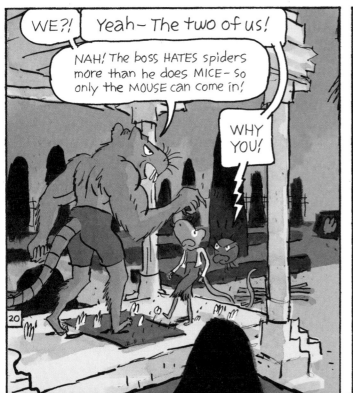

WE?!

Yeah— The two of us!

NAH! The boss HATES spiders more than he does MICE— So only the MOUSE can come in!

WHY YOU!

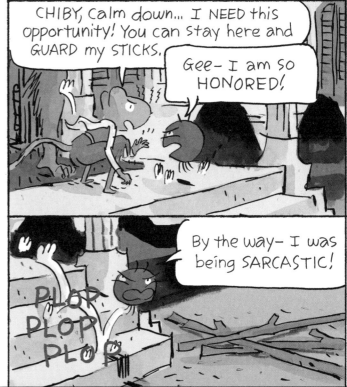

CHIBY, calm down... I NEED this opportunity! You can stay here and GUARD my STICKS.

Gee— I am so HONORED!

By the way— I was being SARCASTIC!

PLOP PLOP PLOP

20

Follow me, PAINTER!

I'm right behind you!

And don't touch NOTH'N EITHER!

Don't WORRY, I won't!

Gulp.

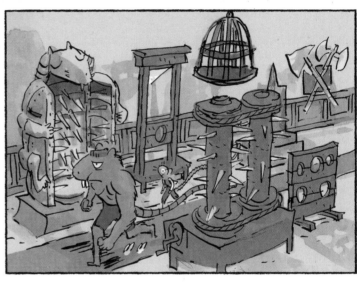

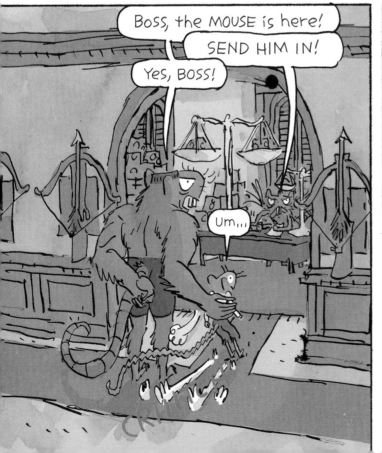

Boss, the MOUSE is here!

SEND HIM IN!

Yes, BOSS!

Um....

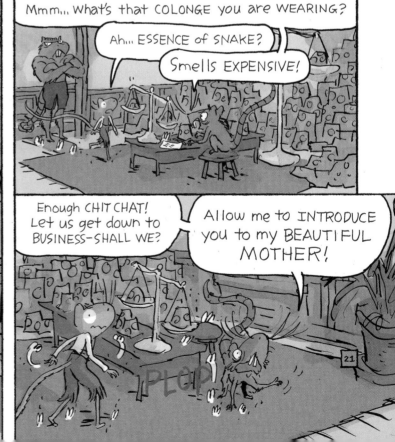

Mmm.... what's that COLONGE you are WEARING?

Ah... ESSENCE of SNAKE?

Smells EXPENSIVE!

Enough CHIT CHAT! Let us get down to BUSINESS—SHALL WE?

Allow me to INTRODUCE you to my BEAUTIFUL MOTHER!

21

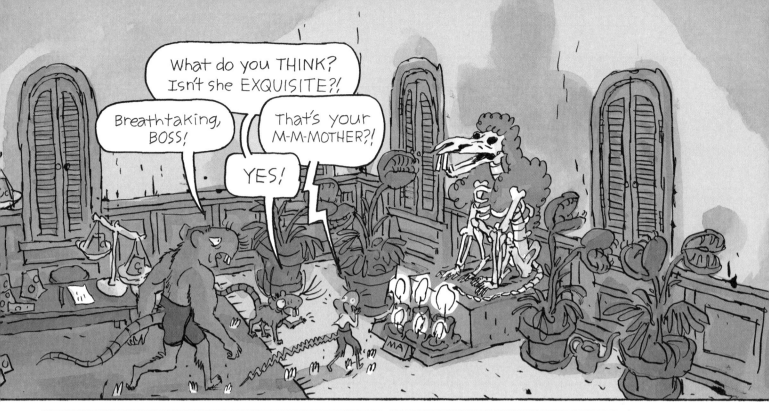

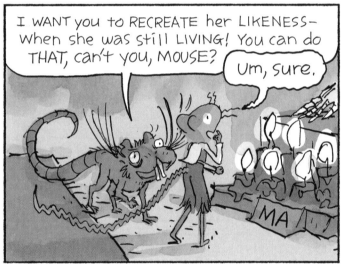

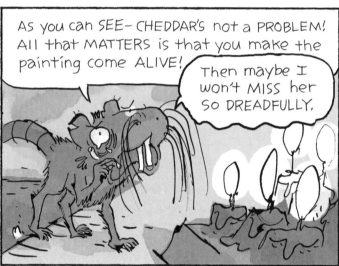

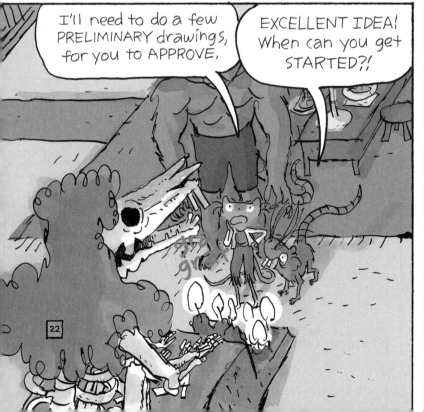

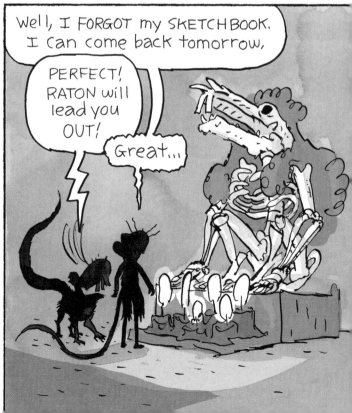

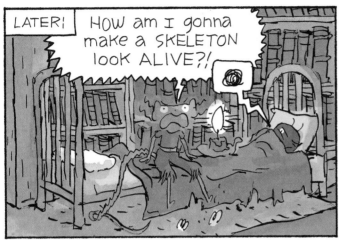

LATER! HOW am I gonna make a SKELETON look ALIVE?!

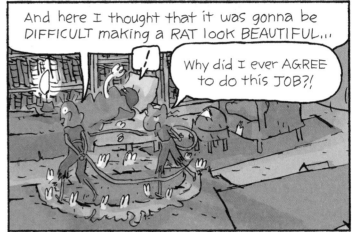

And here I thought that it was gonna be DIFFICULT making a RAT look BEAUTIFUL...

Why did I ever AGREE to do this JOB?!

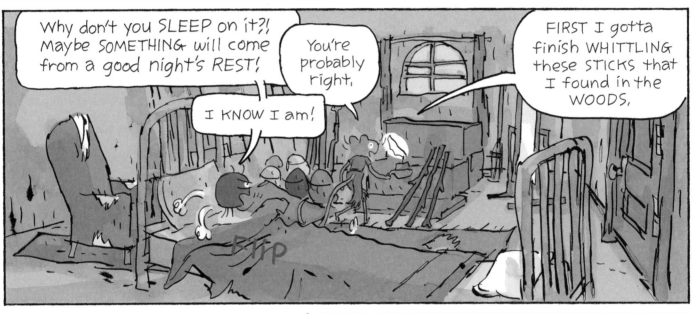

Why don't you SLEEP on it?! Maybe SOMETHING will come from a good night's REST!

You're probably right.

I KNOW I am!

FIRST I gotta finish WHITTLING these STICKS that I found in the WOODS.

Plip

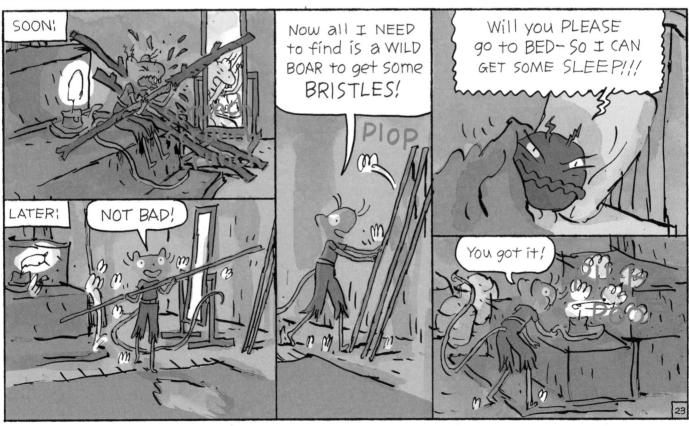

SOON!

LATER! NOT BAD!

Now all I NEED to find is a WILD BOAR to get some BRISTLES!

Plop

Will you PLEASE go to BED—SO I CAN GET SOME SLEEP!!!

You got it!

23

Sigh...

ZZZ...

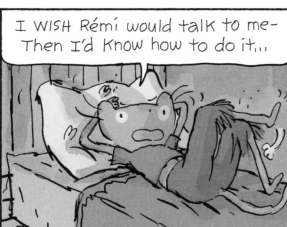

I WISH Rémi would talk to me— Then I'd Know how to do it...

Oh well... YAWN!

Z

ZZZ...

MUS...

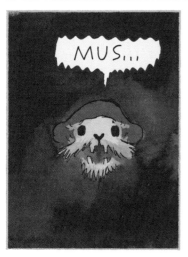

MUS...

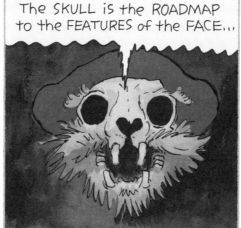

The SKULL is the ROADMAP to the FEATURES of the FACE...

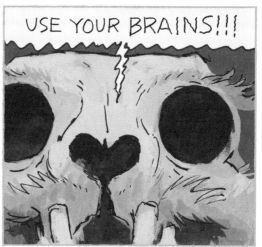

USE YOUR BRAINS!!!

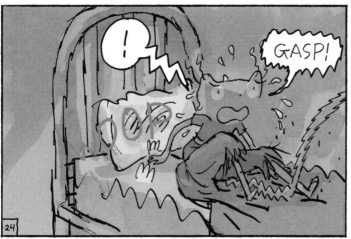

!

GASP!

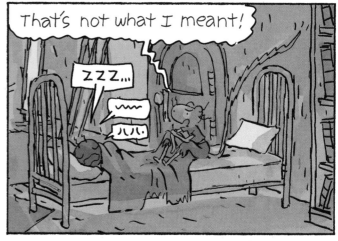

That's not what I meant!

ZZZ...

24

THE NEXT MORNING!

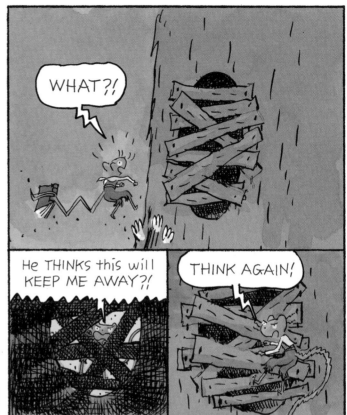

WHAT?!

He THINKS this will KEEP ME AWAY?!

THINK AGAIN!

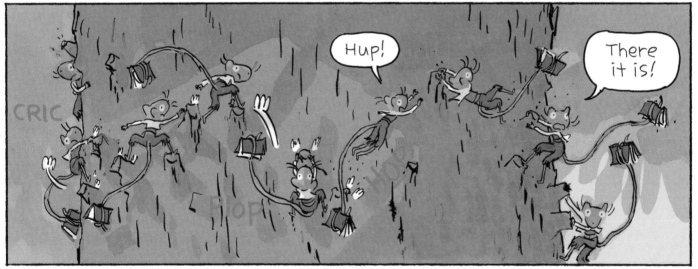

HUP!

There it is!

CRIC

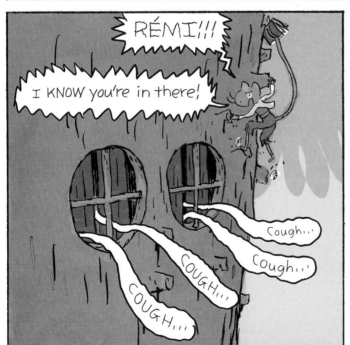

RÉMI!!!

I KNOW you're in there!

Cough...

Cough...

COUGH...

COUGH...

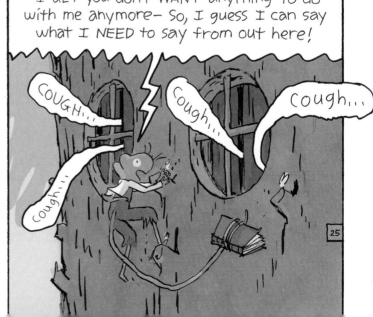

I GET you don't WANT anything to do with me anymore— So, I guess I can say what I NEED to say from out here!

COUGH...

Cough...

Cough...

Cough...

25

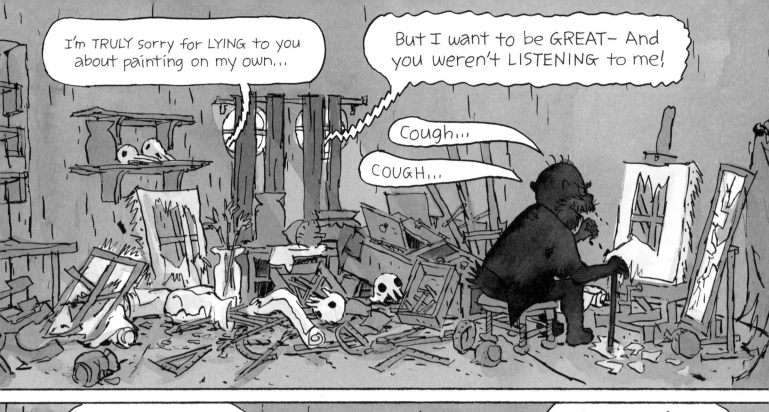

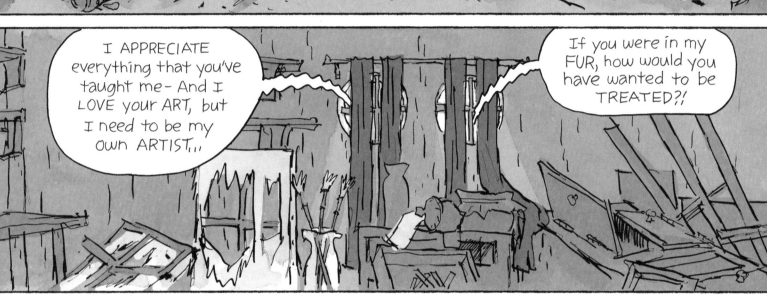

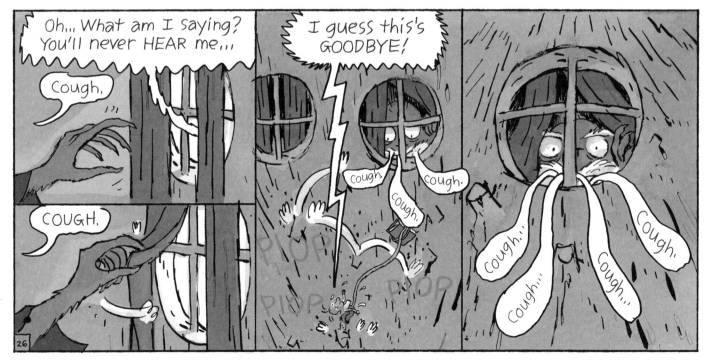

26

ELSEWHERE!

Hey, REUIL!

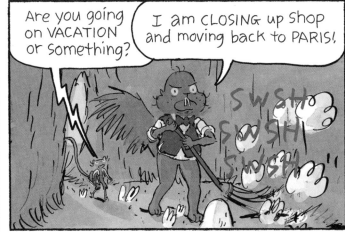

Are you going on VACATION or something?

I am CLOSING up shop and moving back to PARIS!

SWSH SWSH SWSH

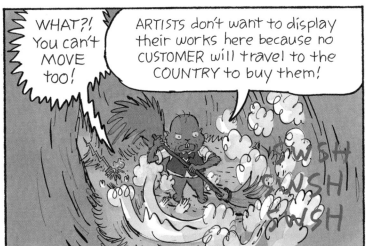

WHAT?! You can't MOVE too!

ARTISTS don't want to display their works here because no CUSTOMER will travel to the COUNTRY to buy them!

SWSH SWSH SWSH

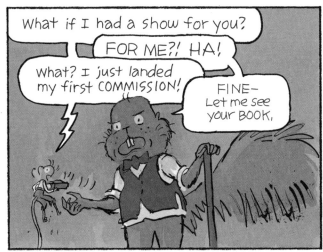

What if I had a show for you?

FOR ME?! HA!

What? I just landed my first COMMISSION!

FINE— Let me see your BOOK.

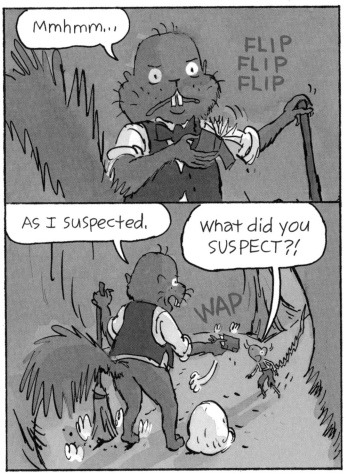

Mmhmm...

FLIP FLIP FLIP

As I suspected.

What did you SUSPECT?!

WAP

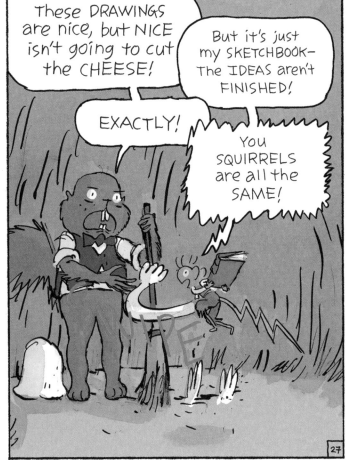

These DRAWINGS are nice, but NICE isn't going to cut the CHEESE!

But it's just my SKETCHBOOK— The IDEAS aren't FINISHED!

EXACTLY!

You SQUIRRELS are all the SAME!

27

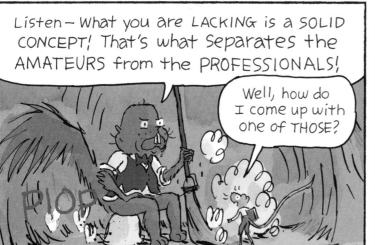

Listen— What you are LACKING is a SOLID CONCEPT! That's what Separates the AMATEURS from the PROFESSIONALS!

Well, how do I come up with one of THOSE?

PLOP

Kid, if I knew that, I would be on the other side of the HAYSTACK!

Oh...

If you want to be SUCCESSFUL, you'll need to give them a little SHOCK and AWE!

Then the BUYERS will have to pay ATTENTION!

The RODENT ART COMMUNITY would AWAKE from their HIBERNATION and travel from FAR and NEAR!

Sigh...

But you're not going to ATTRACT anyone with BAIT like that!

I see...

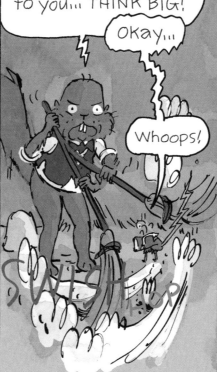

So my FINAL advice to you... THINK BIG!

Okay...

Whoops!

SWISH

Reuil, do you know any WILD BOARS that live in the area?

Sorry, Kid, I only DEAL with RODENTS!

Okay, cough...

SWISH SWISH

28

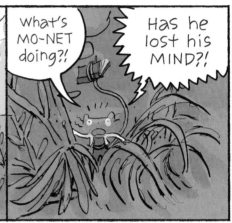

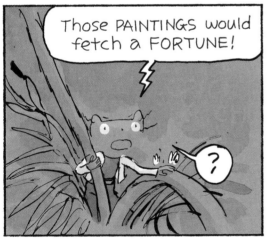

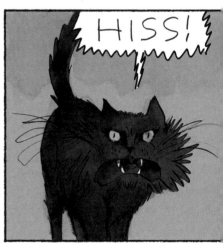

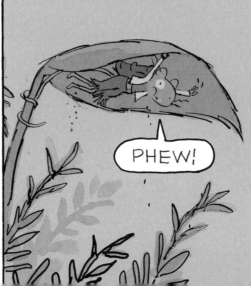

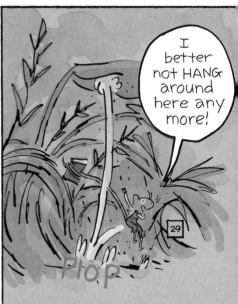

LATER!

The SKULL is the MAP to the FACE...

YEAH RIGHT!

This is IMPOSSIBLE!

Come on, MUS— Don't QUIT now!

Think of MYA and her FAMILY! USE YOUR INTELLIGENCE!

SOON!

Better...

But I won't know for sure until I get his APPROVAL!

Hey, MUSCLES! where's your BOSS?

ZZZ

Okay... I'll have to find him on my own!

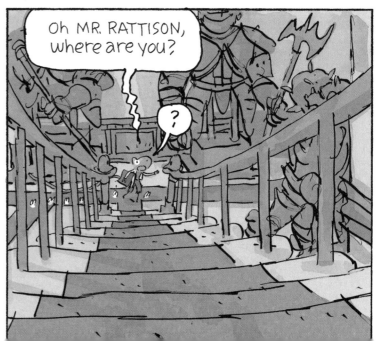

Oh MR. RATTISON, where are you?

30

ARE YOU UP HERE, SIR?!

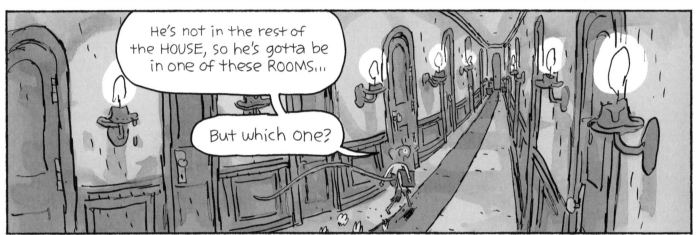

He's not in the rest of the HOUSE, so he's gotta be in one of these ROOMS...

But which one?

NO. NO. NO...

!

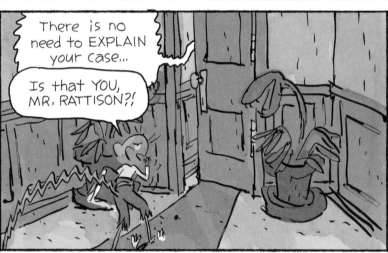

There is no need to EXPLAIN your case...

Is that YOU, MR. RATTISON?!

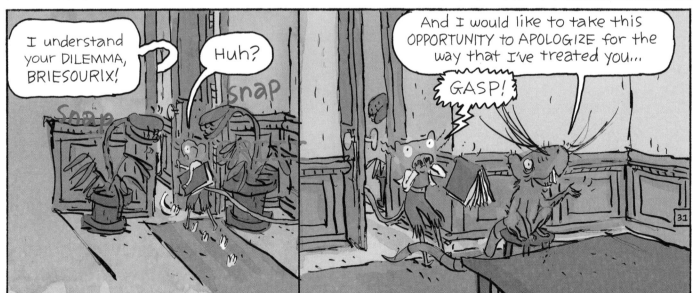

I understand your DILEMMA, BRIESOURIX!

Huh?

Snap

Sapp

And I would like to take this OPPORTUNITY to APOLOGIZE for the way that I've treated you...

GASP!

31

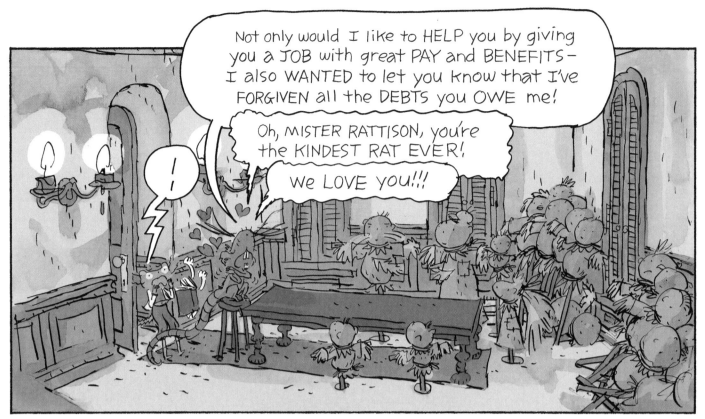

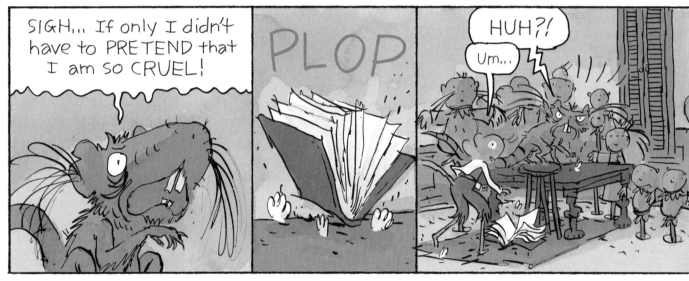

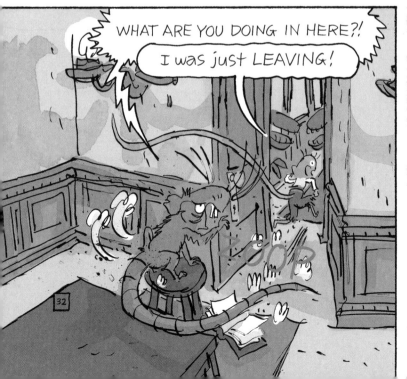

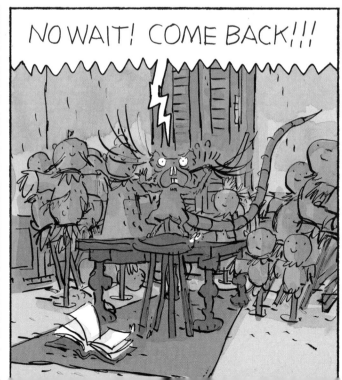

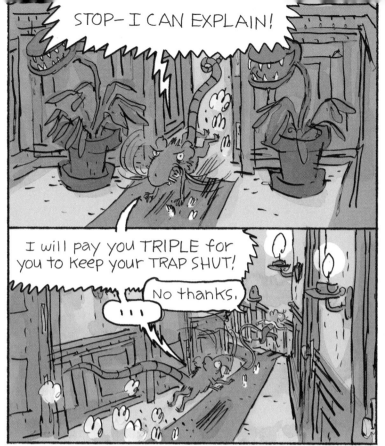

STOP— I CAN EXPLAIN!

I will pay you TRIPLE for you to keep your TRAP SHUT!

No thanks.

...!

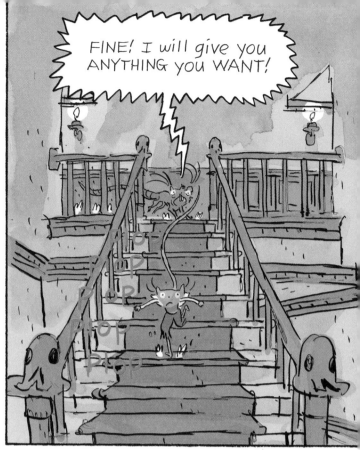

FINE! I will give you ANYTHING you WANT!

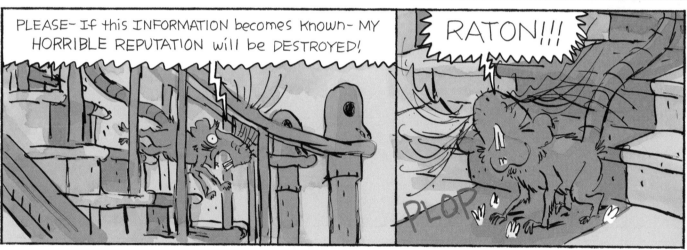

PLEASE— If this INFORMATION becomes known— MY HORRIBLE REPUTATION will be DESTROYED!

RATON!!!

PLOP

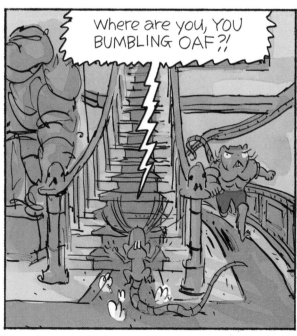

Where are you, YOU BUMBLING OAF?!

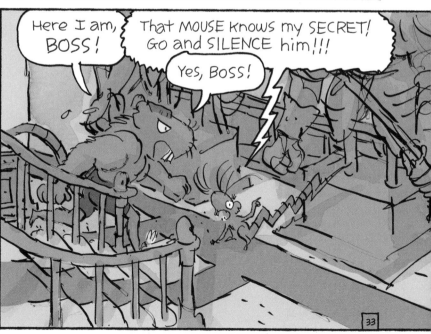

Here I am, BOSS!

That MOUSE knows my SECRET! Go and SILENCE him!!!

Yes, BOSS!

33

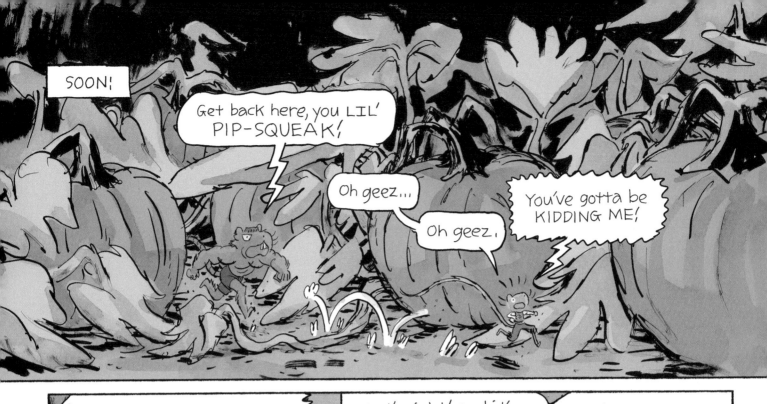

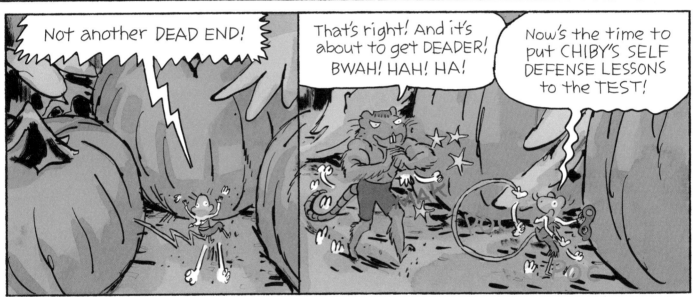

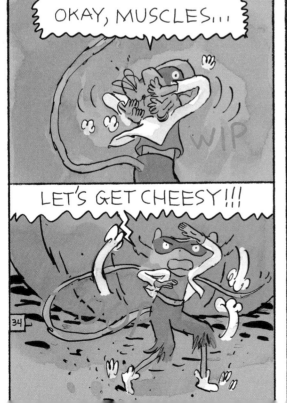

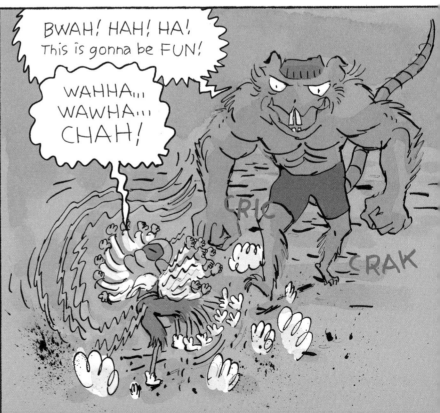

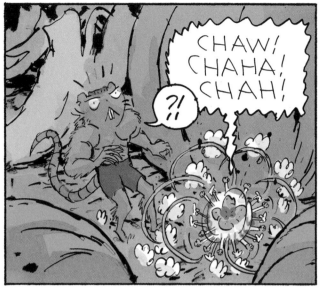

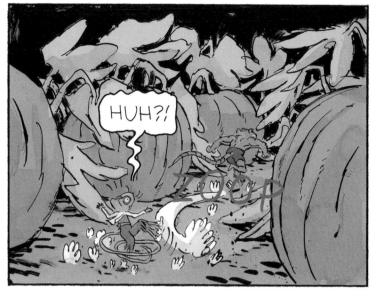

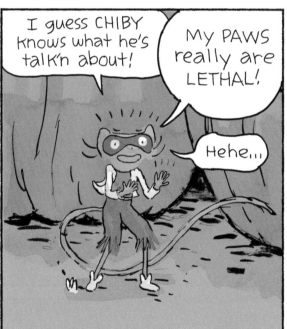

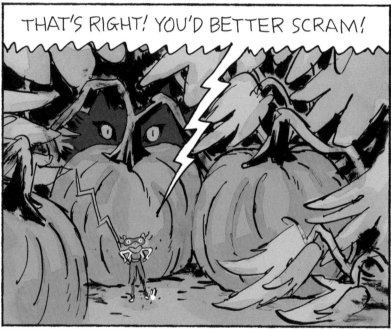

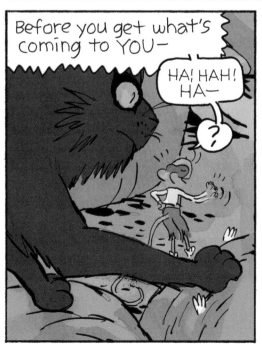

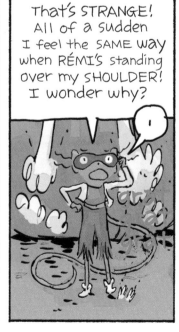

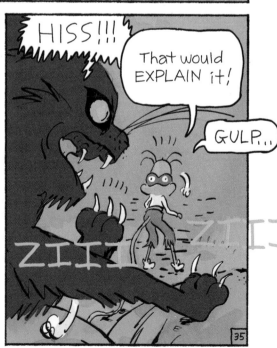

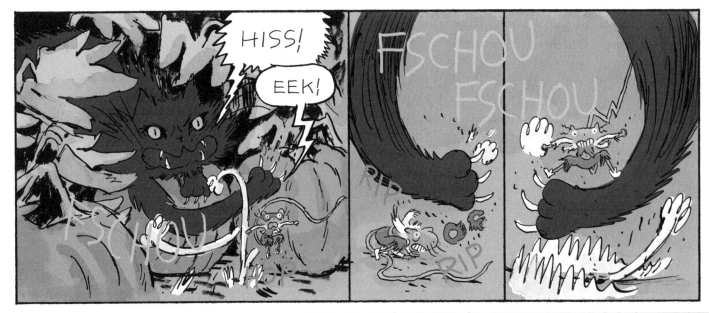

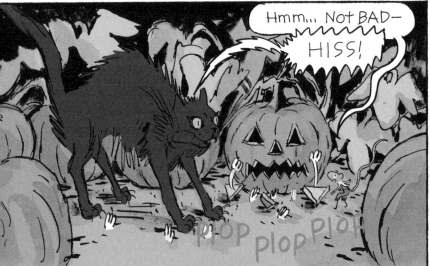

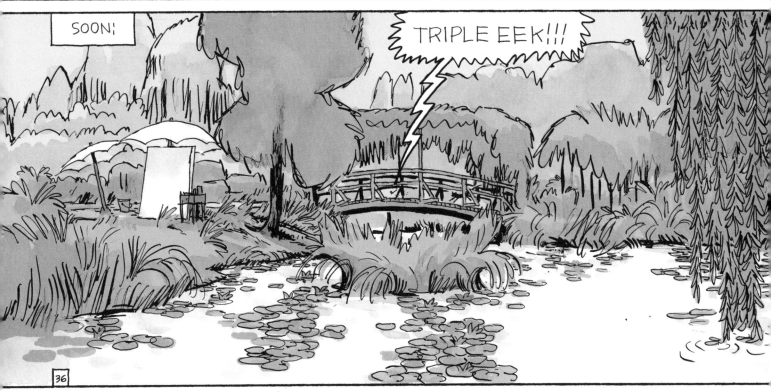

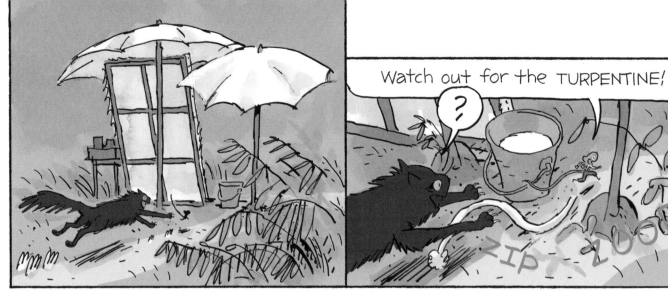

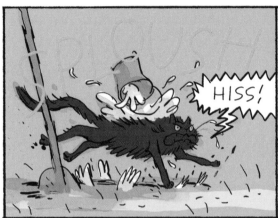

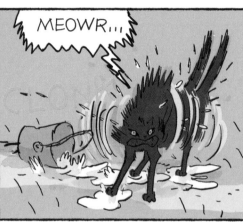

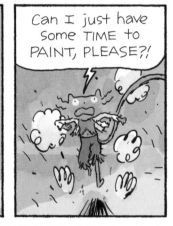

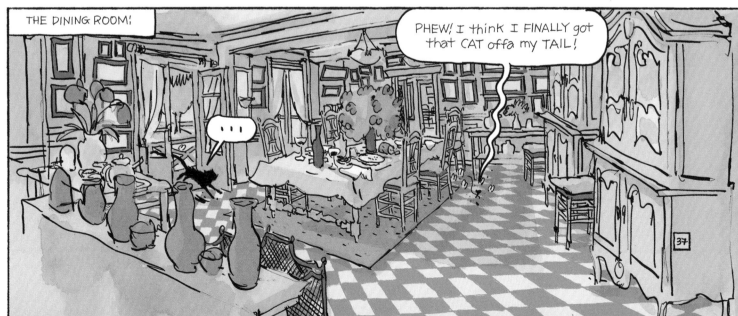

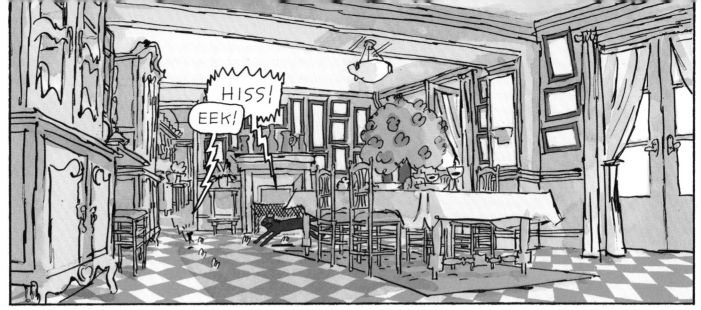

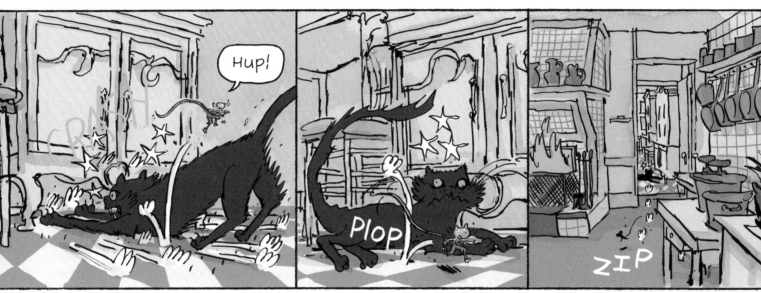

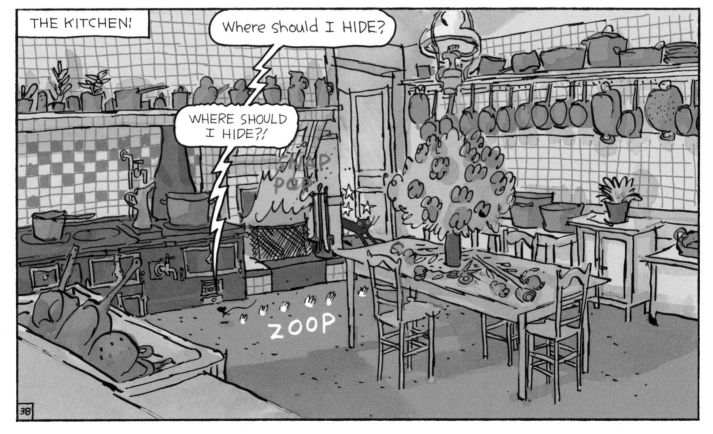

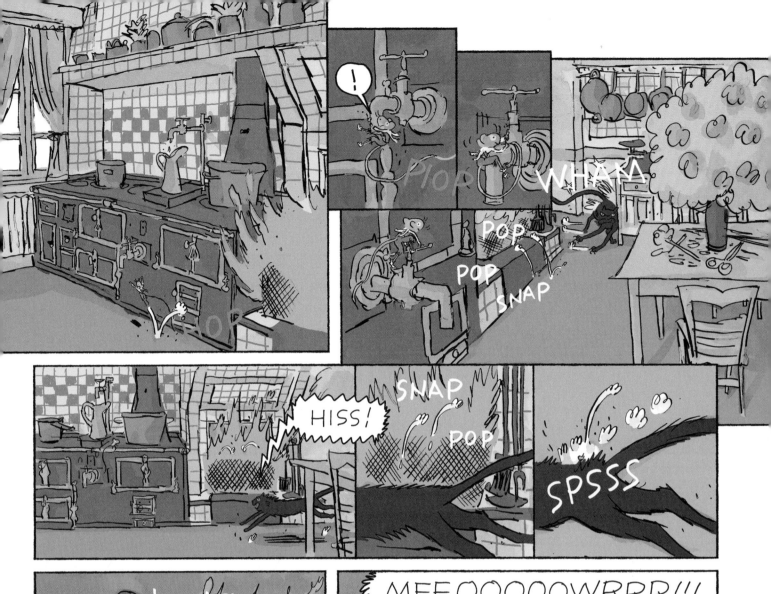

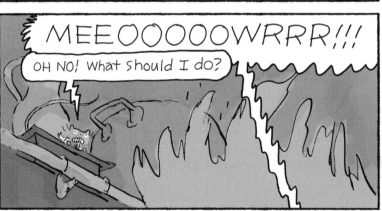

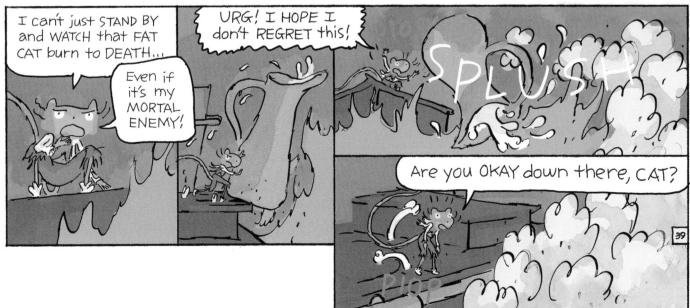

39

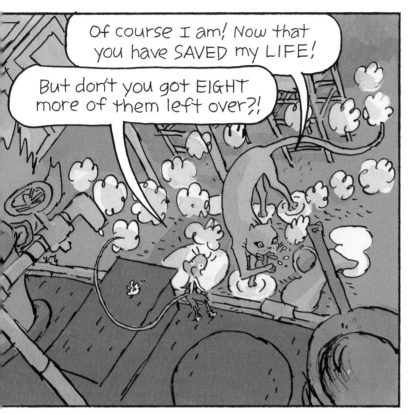

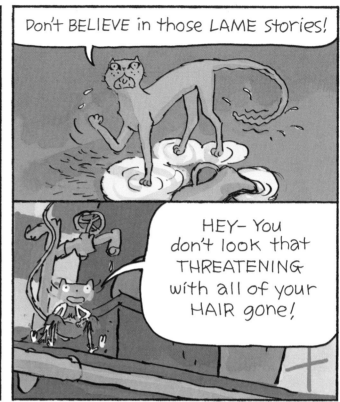

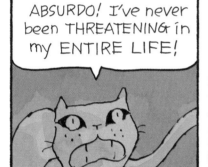

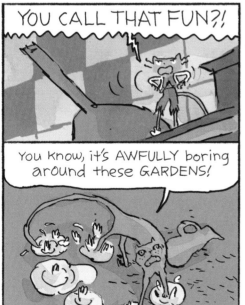

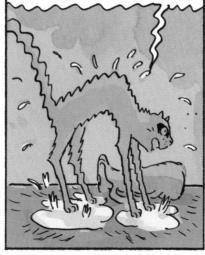

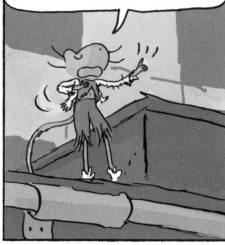

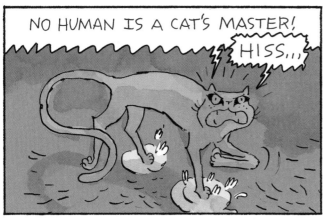

NO HUMAN IS A CAT'S MASTER!

HISS...

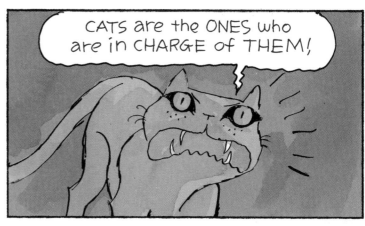

CATS are the ONES who are in CHARGE of THEM!

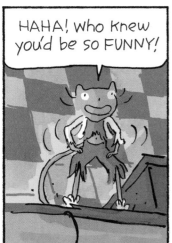

HAHA! Who knew you'd be so FUNNY!

I'm not TRYING to be! Now please come down, so I can properly THANK YOU!

Um...

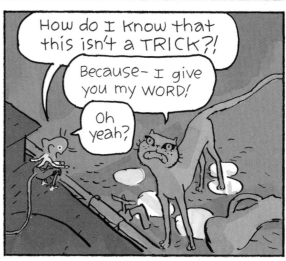

How do I know that this isn't a TRICK?!

Because— I give you my WORD!

Oh yeah?

Si! And a CAT'S WORD is it's BOND!

Besides, don't you realize that I could've already come up there and FILLETED you to the BONE?!

JAJA!

ZIII

I guess you've got a good POINT...

Gulp.

grat grat grat

I'll TRUST you, but be AWARE, I've got Some SCARY NINJA MOVES!

Yeah, I SAW your TECHNIQUE and you Should stick to making ART!

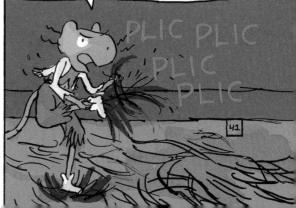

URG! I got your BURNT HAIR all over my WEB SHOES! I'll have to ask CHIBY to make me another PAIR...

41

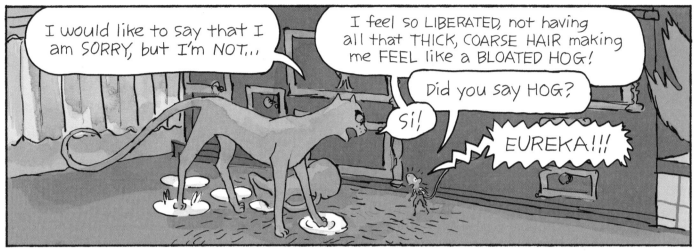

I would like to say that I am SORRY, but I'm NOT...

I feel so LIBERATED, not having all that THICK, COARSE HAIR making me FEEL like a BLOATED HOG!

Did you say HOG?

Si!

EUREKA!!!

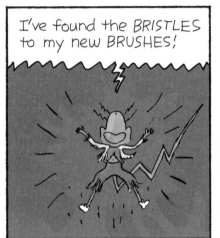

I've found the BRISTLES to my new BRUSHES!

Oh— You don't mind if I keep your BURNT HAIR, do you?

HELP YOURSELF! After all, I am FOREVER in your DEBT!

Gee, I don't know about THAT.

I mean it! And I'd like to show my GRATITUDE by showing you where MONET keeps his BEST SCRAPS! But we should hurry, before he sees me and is SHOCKED by my APPEARANCE!

WAIT—

You just gave me the greatest IDEA!

Why are you looking at me that WAY?! It's downright EERIE!

Come close and I'll tell you, but you gotta keep it a SECRET!

Ooh... I like SECRETOS!

Whisper, whisper, whisper

Uh-huh...

Uh-huh...

THAT'S PERRRFECTO! I can help you with all of that!

Then let's get STARTED!

OKAY!

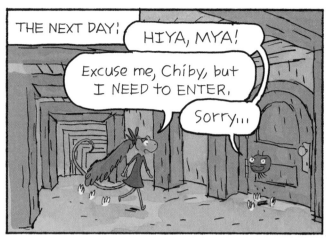

THE NEXT DAY!

HIYA, MYA!

Excuse me, Chiby, but I NEED to ENTER.

Sorry...

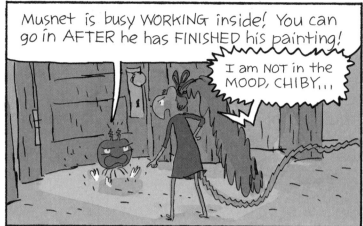

Musnet is busy WORKING inside! You can go in AFTER he has FINISHED his painting!

I am NOT in the MOOD, CHIBY...

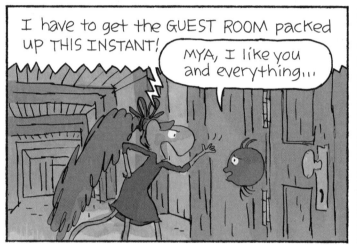

I have to get the GUEST ROOM packed up THIS INSTANT!

MYA, I like you and everything...

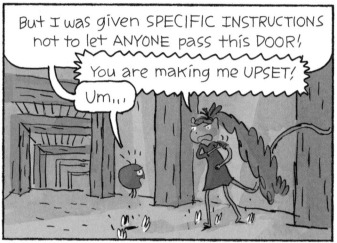

But I was given SPECIFIC INSTRUCTIONS not to let ANYONE pass this DOOR!

You are making me UPSET!

Um...

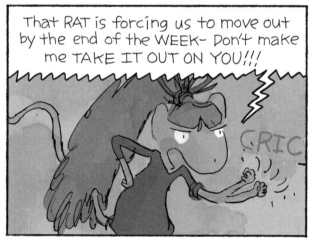

That RAT is forcing us to move out by the end of the WEEK— Don't make me TAKE IT OUT ON YOU!!!

CRIC

Gulp, Okay, you can PASS.

That's more like it!

WET CANVAS COMING THROUGH!

PLOP

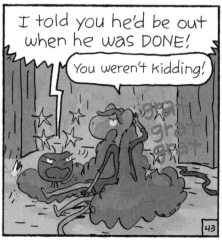

I told you he'd be out when he was DONE!

You weren't kidding!

SOON;

SO? How did it TURN OUT from the drawings that you made?

We'll SEE!

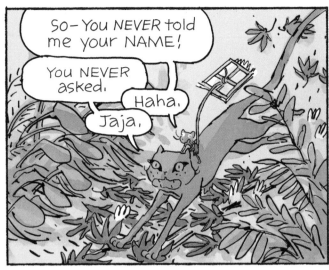

So— You NEVER told me your NAME!

You NEVER asked.

Haha.

Jaja.

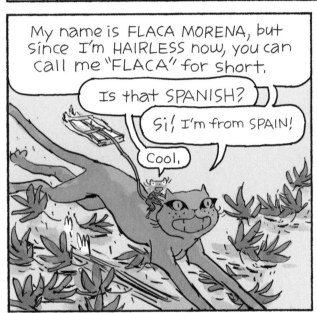

My name is FLACA MORENA, but since I'm HAIRLESS now, you can call me "FLACA" for short.

Is that SPANISH?

Si! I'm from SPAIN!

Cool.

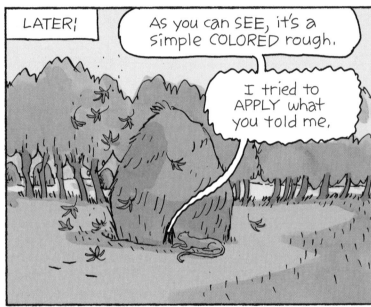

LATER!

As you can SEE, it's a simple COLORED rough.

I tried to APPLY what you told me.

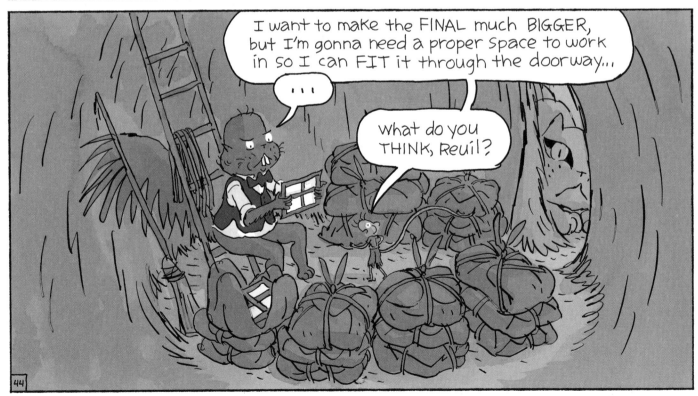

I want to make the FINAL much BIGGER, but I'm gonna need a proper space to work in so I can FIT it through the doorway...

...

what do you THINK, Reuil?

44

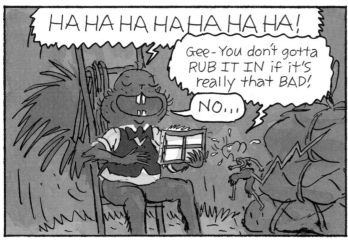

HA HA HA HA HA HA HA!

Gee—You don't gotta RUB IT IN if it's really that BAD!

NO...

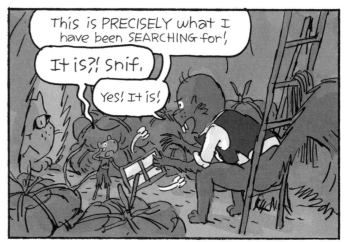

THIS is PRECISELY what I have been SEARCHING for!

It is?! Snif.

Yes! It is!

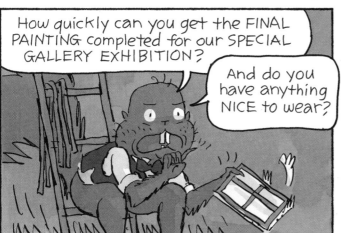

How quickly can you get the FINAL PAINTING completed for our SPECIAL GALLERY EXHIBITION?

And do you have anything NICE to wear?

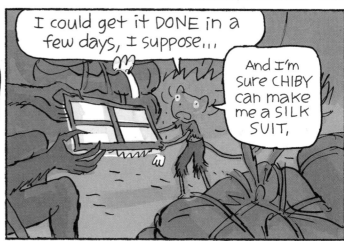

I could get it DONE in a few days, I suppose...

And I'm sure CHIBY can make me a SILK SUIT.

That should allow me enough time to turn this into the GRANDEST EVENT that any RODENT has ever WITNESSED!

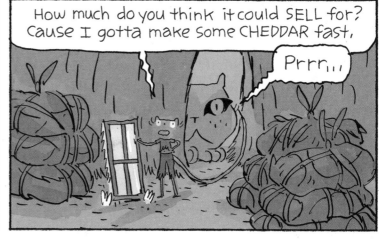

How much do you think it could SELL for? Cause I gotta make some CHEDDAR fast.

Prrr...

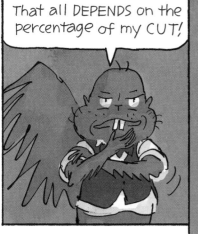

That all DEPENDS on the percentage of my CUT!

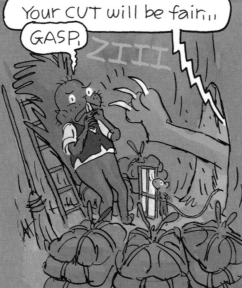

Your CUT will be fair...

GASP.

ZIII

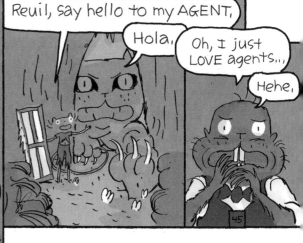

Reuil, say hello to my AGENT.

Hola.

Oh, I just LOVE agents...

Hehe.

45

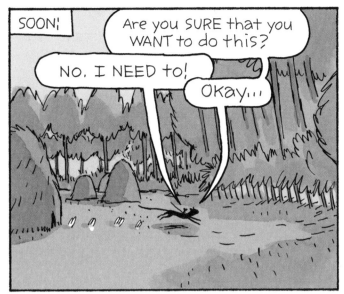

SOON:

Are you SURE that you WANT to do this?

NO, I NEED to!

Okay...

?

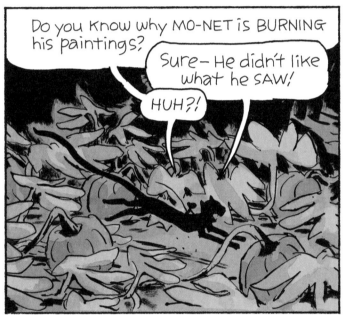

Do you know why MO-NET is BURNING his paintings?

Sure— He didn't like what he SAW!

HUH?!

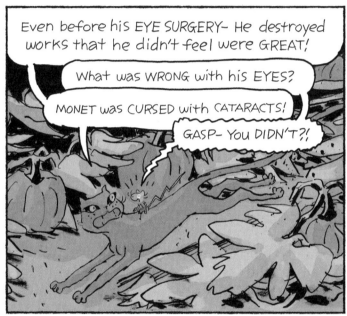

Even before his EYE SURGERY— He destroyed works that he didn't feel were GREAT!

What was WRONG with his EYES?

MONET was CURSED with CATARACTS!

GASP— You DIDN'T?!

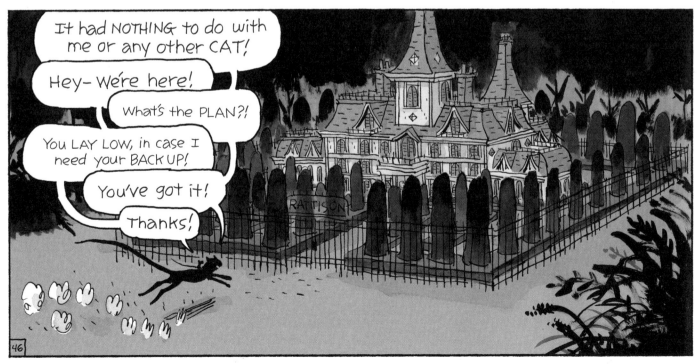

It had NOTHING to do with me or any other CAT!

Hey— We're here!

What's the PLAN?!

You LAY LOW, in case I need your BACK UP!

You've got it!

Thanks!

46

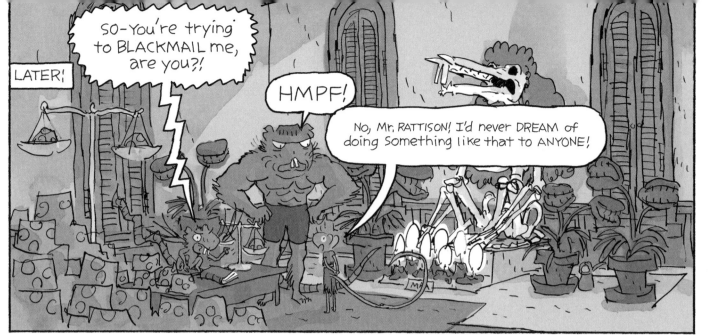

SO-You're trying to BLACKMAIL me, are you?!

LATER!

HMPF!

No, Mr. RATTISON! I'd never DREAM of doing Something like that to ANYONE!

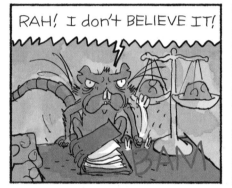

RAH! I don't BELIEVE IT!

I don't see what the BIG DEAL is— WHO CARES if you wanna be NICE?!

No RODENT will RESPECT HIM!

He'll be SHUNNED!

Be QUIET! I can take care of THIS MYSELF!

Sorry, BOSS.

Well, I'm not the most POSITIVE mouse to be around all the time—Just ask my FRIENDS. If you'd like, WE could make a PACT and try to work on it TOGETHER?

How's that for a CONCEPT?

How do I Know that I can trust you, MOUSE?!

Because, SIR—MY WORD IS MY BOND!

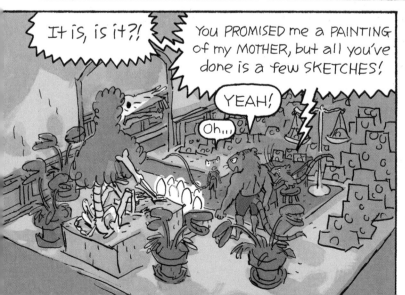

It is, is it?!

YOU PROMISED me a PAINTING of my MOTHER, but all you've done is a few SKETCHES!

YEAH!

Oh...

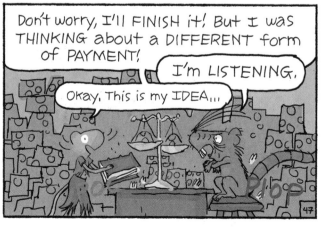

Don't worry, I'll FINISH it! But I was THINKING about a DIFFERENT form of PAYMENT!

I'm LISTENING.

Okay. This is my IDEA...

ONE WEEK LATER!

OPENING NIGHT!

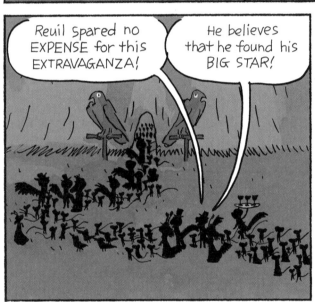

Reuil spared no EXPENSE for this EXTRAVAGANZA!

He believes that he found his BIG STAR!

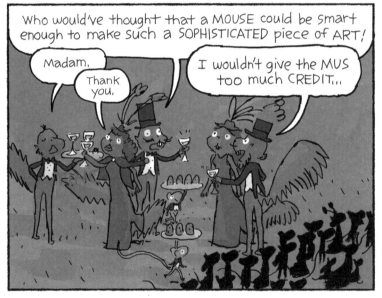

Who would've thought that a MOUSE could be smart enough to make such a SOPHISTICATED piece of ART!

Madam.

Thank you.

I wouldn't give the MUS too much CREDIT...

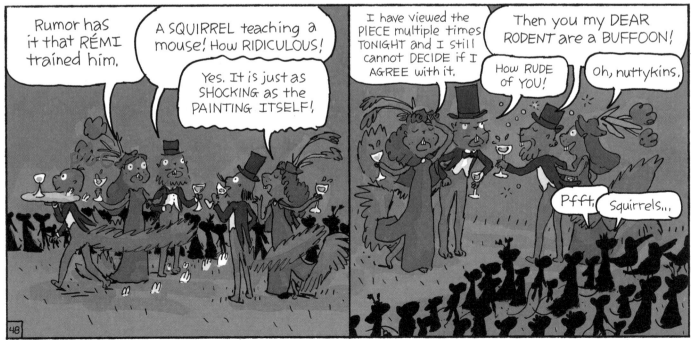

Rumor has it that RÉMI trained him.

A SQUIRREL teaching a mouse! How RIDICULOUS!

Yes. It is just as SHOCKING as the PAINTING ITSELF!

I have viewed the PIECE multiple times TONIGHT and I still cannot DECIDE if I AGREE with it.

Then you my DEAR RODENT are a BUFFOON!

How RUDE of YOU!

Oh, nuttykins.

Pfft. Squirrels...

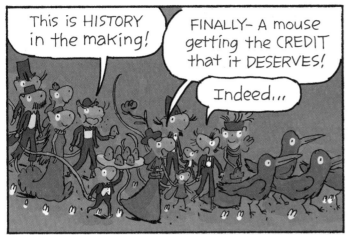

This is HISTORY in the making!

FINALLY— A mouse getting the CREDIT that it DESERVES!

Indeed...

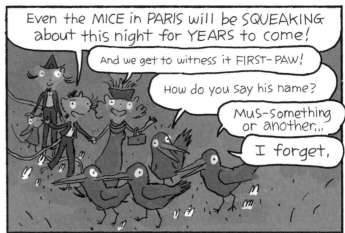

Even the MICE in PARIS will be SQUEAKING about this night for YEARS to come!

And we get to witness it FIRST-PAW!

How do you say his name?

Mus-something or another...

I forget.

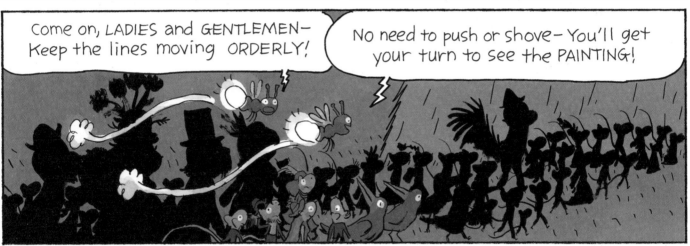

Come on, LADIES and GENTLEMEN— Keep the lines moving ORDERLY!

No need to push or shove— You'll get your turn to see the PAINTING!

It sure is nice to have our old JOBS back! And we're gonna play some CARDS afterwards, RIGHT?

You bet your GLOWING BUTT we are! And I see that you're still not very BRIGHT!

HAHA!

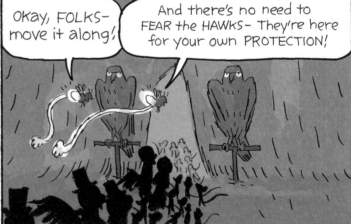

Okay, FOLKS— move it along!

And there's no need to FEAR the HAWKS— They're here for your own PROTECTION!

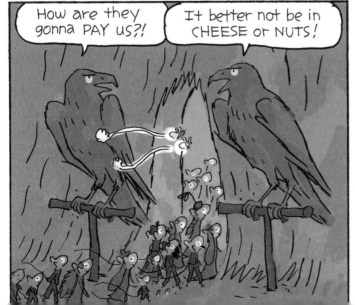

How are they gonna PAY us?!

It better not be in CHEESE or NUTS!

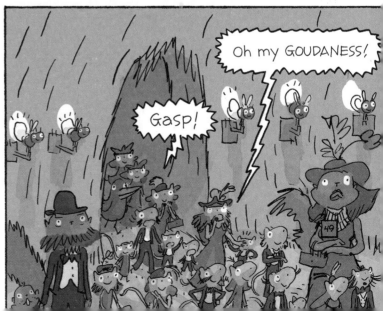

Oh my GOUDANESS!

Gasp!

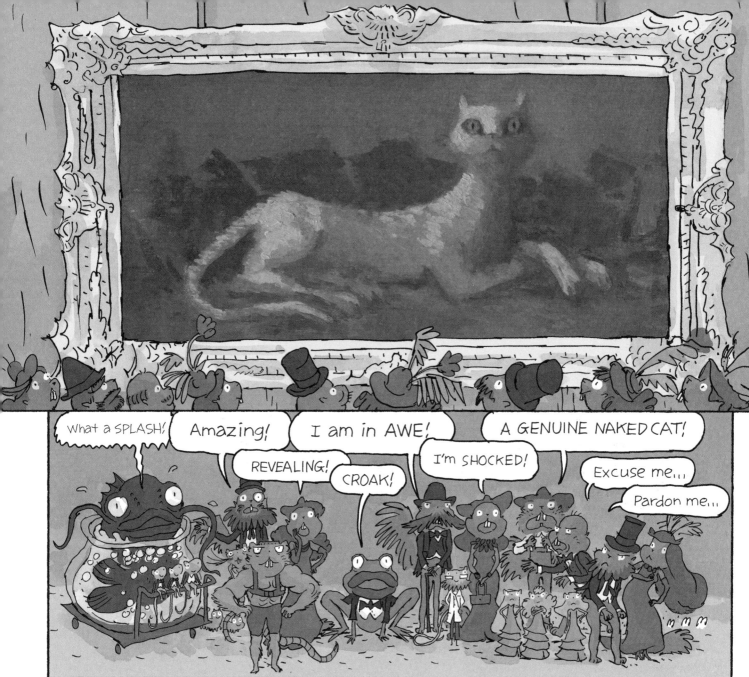

What a SPLASH!

Amazing!

I am in AWE!

A GENUINE NAKED CAT!

REVEALING!

CROAK!

I'm SHOCKED!

Excuse me...

Pardon me...

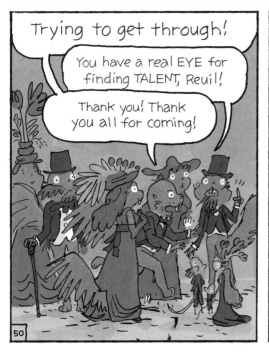

Trying to get through!

You have a real EYE for finding TALENT, Reuil!

Thank you! Thank you all for coming!

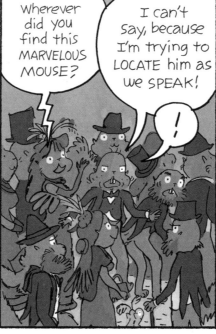

Wherever did you find this MARVELOUS MOUSE?

I can't say, because I'm trying to LOCATE him as we SPEAK!

!

There you ARE! I have such great NEWS to inform you about, Musnet...

?

50

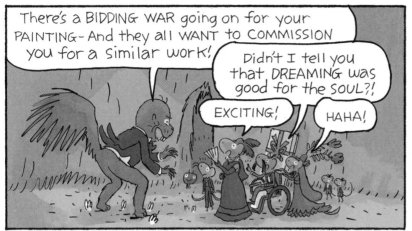
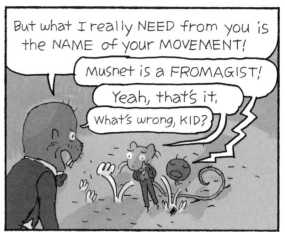
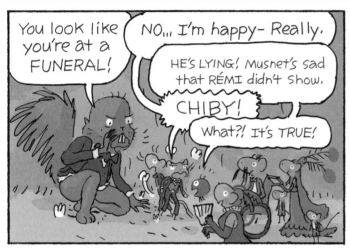
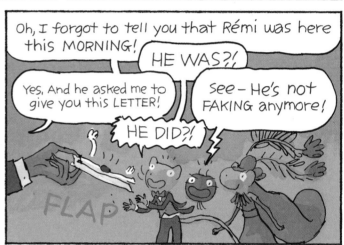
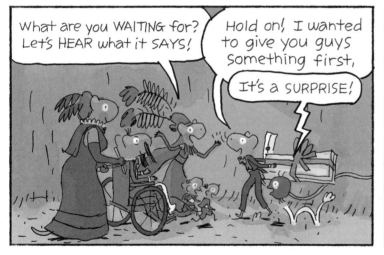
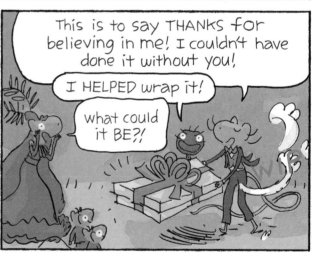
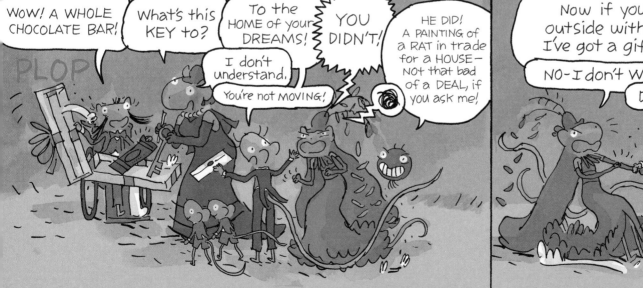

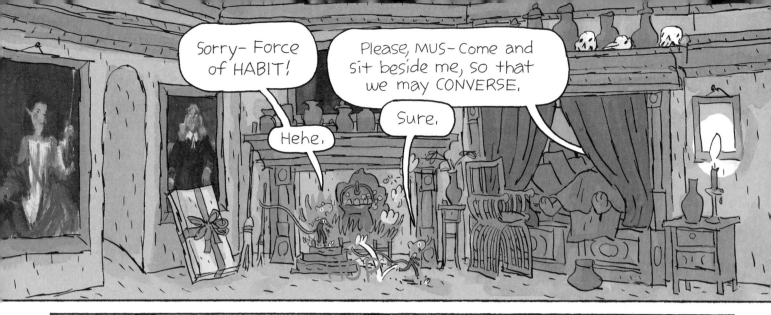

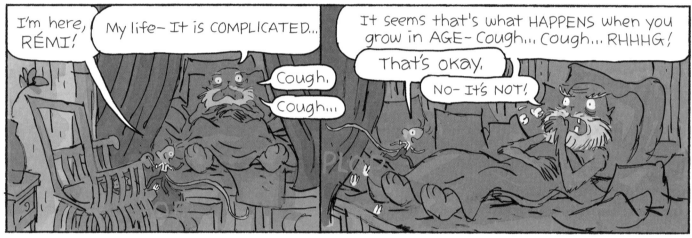

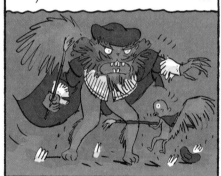

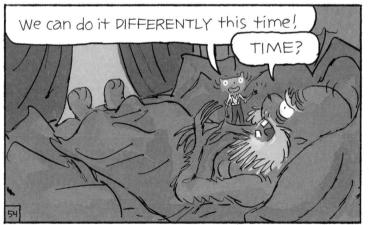

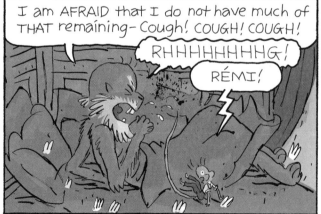

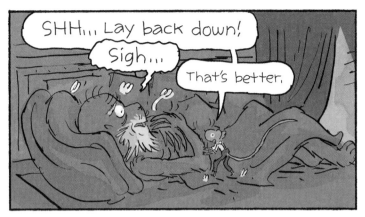

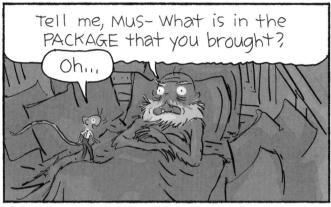

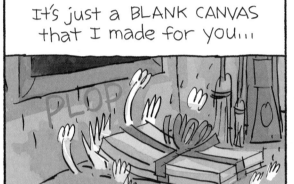

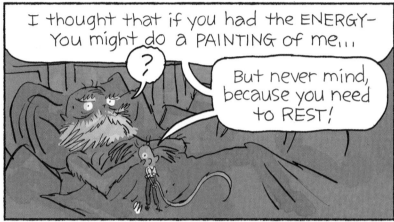

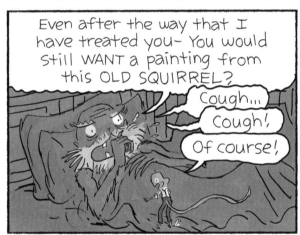

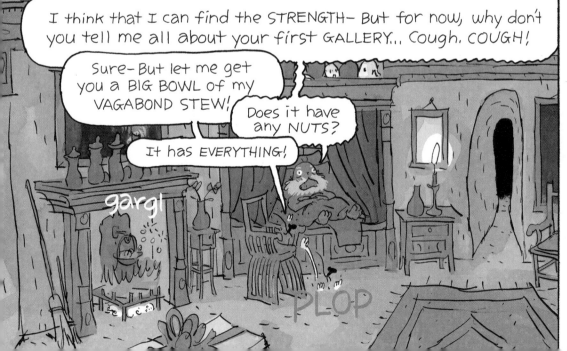

Goodbye, HOUSE...

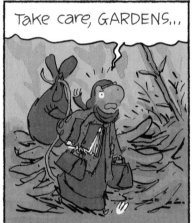

Take care, GARDENS...

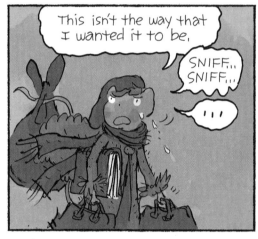

This isn't the way that I wanted it to be.

SNIFF...
SNIFF...

...

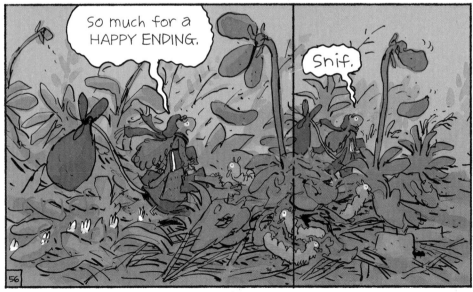

So much for a HAPPY ENDING.

Snif.

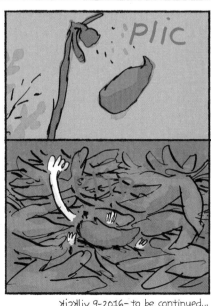

plic

56

kiDkliy 9-2016- to be continued...